harina Fritsch

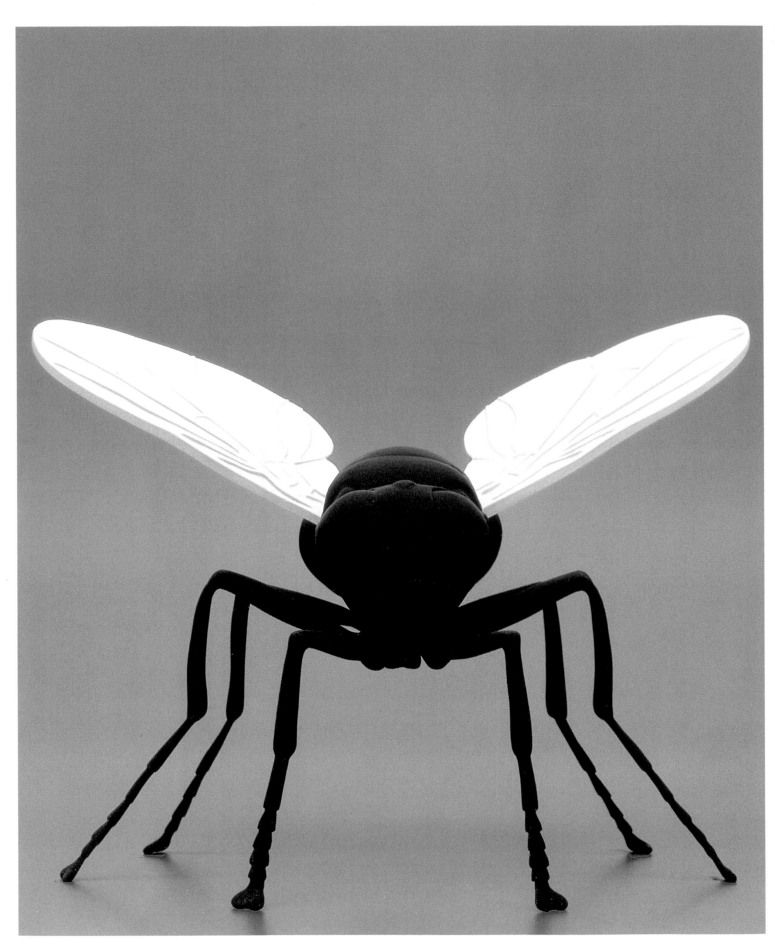

Fliege (*Fly*), 2000
Plastic, paint
25 × 20 × 20 cm (9⅞ × 7⅞ × 7⅞ in)

Katharina Fritsch

Edward Allington, Susanne Bieber,
Iwona Blazwick, Bice Curiger
and Julian Heynen

Edited by Iwona Blazwick

TATE PUBLISHING

Supported by
Institut für Auslandsbeziehungen
Stiftung Kunst und Kultur Nordrhein-Westfalen
Henry Moore Foundation

Front cover: *Dealer (Händler)*, 2001 (detail)
Back cover: *Heart with Silver (Herz mit Silber)*, 1998/9
(detail)

Published by order of the Tate Trustees 2002
on the occasion of the exhibition at Tate Modern, London,
7 September to 5 December 2001 and Ständehaus,
Düsseldorf, 20 April to 8 September 2002

ISBN 1 85437 363 3

A catalogue record for this publication is available
from the British Library

Published by Tate Publishing, a division of
Tate Enterprises Ltd, Millbank, London SW1P 4RG

For other copyright and photographic credits see p.127

Catalogue design by Peter B. Willberg

Printed and bound in Great Britain by Balding + Mansell,
Norwich

Artist's Acknowledgements
Peter Josef Abels, Heinz and Simone Ackermans, Olivia
Berckemeyer, Susanne Bieber, Daniel Birkner, Elisabeth
Bushart, Klaus Czyrnik, Stephanie Dorsey, Andrej Dureika,
Dmitri Dykhovitchni, Frank Fenstermacher, Erich Gantzert,
Anna Giese, Tita Giese, Ryan Hart, Martin Hentschel, Martin Huidobro, Dr. Gudrun Inboden, Jay Jopling, Herr K.,
Claudia van Koolwijk, Alexej Koschkarow, Maja Mauzi, Phil
Monk and crew, Dr. Stephan Motzer, Susanne Pfleger,
Arne Reimann, Firma Roggendorf, Dirk Specht, Firma HV
Stoll, Jill Sussman, Nic and Ruth Tenwiggenhorn, Sophie
Tiercelin, Firma Vacumetallic, Die Tanteiden aus Zürich und
Die Nanis

Contents

Foreword

This exhibition is the first monographic show of a contemporary artist at Tate Modern. It reflects Tate's commitment to presenting new developments in international contemporary art. We believe that Katharina Fritsch is one of the most important artists to emerge in Europe during the last twenty years, and this mid-career survey gives British and international audiences a rare opportunity to discover and explore her work in all its facets.

The sculpture of Katharina Fritsch is often stunning at first sight. Encounters with her work, such as *Elephant*, *Company at Table* or *Monk*, stimulate a vivid visual and emotional reaction. Generally Fritsch conceives her sculptures as an immaterial picture in her mind's eye, which is later re-created in three dimensional form with minute attention to form, proportion and colour. Her completed sculptures retain the lightness and evanescence of the original visual image. They oscillate between reality and vision, sculpture and image. Her subject matter often derives from the world of myth, religion and fairy tales, and centres on the perennial issues arising from our human condition. Her works strike a deep chord in us, evoking moments of fear and wonder, of life and death, with clarity and concentration.

This exhibition was conceived and realised in close collaboration with Katharina Fritsch, who devoted much time and energy to preparing this show, not only by creating new works but also in responding to our many enquiries while remaining steadfast in her vision for the exhibition. Iwona Blazwick, until recently Head of Exhibitions and Displays at Tate Modern, conceived of this project with eloquence and idealism; the implementation was carried out with enthusiasm and professionalism by Iwona Blazwick and Susanne Bieber, Assistant Curator at Tate Modern, together with Emma Dexter, Senior Curator at Tate Modern.

I am extremely grateful to the numerous institutions and private lenders, who were committed to sharing Fritsch's remarkable works from their collection with a wider audience. Finally I would like to express my great appreciation for the generosity of our financial supporters. The Henry Moore Foundation, the Institute for Foreign Cultural Relations, Stuttgart, and the Arts and Culture Foundation of North Rhine Westfalia provided vital sponsorship. In addition, I would like to thank ZF Josef Roggendorf GmbH who supported this exhibition with a sponsorship in kind. Without such generous contributions we could never have realised the full ambitions of this project.

Nicholas Serota
Director
Tate

Acknowledgements

An exhibition of this scope can only be realised with the support and vision of many individuals and institutions. We would like to thank all those who not only agreed to lend important works from their collections, but also shared with us a commitment to Katharina Fritsch's work. We are very grateful to Simone and Heinz Ackermans, Jean-Christoph Ammann, Peter Fischer, Martin Hentschel, Christian von Holst, Gudrun Inboden, Jacques Kaegi, Mario Kramer, Rolf Lauter, Valeria Liebermann, Maja Oeri, Susanne Pfleger, Sabine Röder, Katharina Schmidt and Guido de Werd.

We are delighted that Julian Heynen, artistic director of the Ständehaus in Düsseldorf has created a partnership with Tate Modern in developing the project and enabling the presentation of the artist's work in her home town. His scholarly contribution to this publication stands alongside the eloquent texts of Edward Allington and Bice Curiger to offer a multi-layered view of the artist's work. Invaluable research has been provided by Tate archivist, Adrian Glew. The graphic vision for this book has been provided by Peter B. Willberg and expert editorial supervision by Nicola Bion, working with Clare Manchester. We are grateful for the creative solutions provided by Kathryn Samson and Philip Miles for interpretative materials and exhibition design. Further thanks to Tim Holton, Stefanie Jansen, Jay Jopling, and Sophie Tiercelin for all their assistance and advice; and to Matthew Marks and his team, especially Stephanie Dorsey and Jill Sussman, for all their work.

We would like to thank former Tate Modern Director, Lars Nittve, for his early commitment and guidance, along with that of colleagues Sheena Wagstaff and Emma Dexter. We are grateful for the expertise and dedication of Phil Monk, Jeremy Dart, Elizabeth McDonald and Nickos Gogolos on the installation, conservation and shipping of works. Thanks also to Andrew Brighton, Caro Howell and Dominic Willsdon for their work in creating the accompanying education and interpretation programmes; to Jennifer Cormack and Lorna Belmore in Development; Bruce Jackson in Finance; Nadine Thompson, Sioban Ketelaar, Penny Hamilton and Jane Scherbaum in Communications; and Brian Gray and Adrian Hardwick in Visitor Services.

Finally, we would like to express our deep gratitude to Katharina Fritsch and her assistants. During the organisation of the exhibition Arne Reimann proved an invaluable source of help and information; throughout the installation we relied upon the diligent work of Matthias Roeser and Dmitri Dykhovchni. We are profoundly indebted to the artist for the passion and engagement she has dedicated to the making of this book, the exhibition and the new works premiered here; and for engaging with us in an inspirational dialogue.

Iwona Blazwick and Susanne Bieber

The Arena of the Image
– Public Works, Imaginary Places

Julian Heynen

In 1990, for an article in an art journal, Katharina Fritsch chose a text by Giorgio de Chirico with the appealing title 'Statues, Furniture and Generals'. In this text we read that 'the geometry of the walls in a museum, of the floors and the ceiling shuts the statue away from the outside world … It is as though we suddenly encounter a ghost.'[1] We gather that de Chirico would find it rather more interesting if the sculptures were standing directly on the floor in the same space as living human beings. He imagines the effect of a figurative sculpture 'sitting in an armchair in one's own home or leaning out of the window'. De Chirico's ideas, which were so new at the time, have since become common currency. What drew Fritsch to this text was the duality of the museum and so-called public spaces, the desire to anchor the artist's three-dimensional works in 'real' life without the works being subsumed in it.

Ever since its earliest beginnings, Fritsch's work has enjoyed a special relationship with the public. It operates in the realm of the experiences, fantasies and images that we all share, and it always takes a stand, albeit in a manner that seems at once open and mysterious. Whether she is dealing with small private objects or substantial architectural structures, Fritsch does her utmost to make her images immediately comprehensible on at least one level. She mediates her ideas through images that we know collectively from the myths, both ancient and modern, attached to religion, cultural history and everyday life. Equally as important is the precision of the forms themselves, which transform largely latent notions into primal images. These are as general as they are memorable, raising the notions embodied in the images above the purely personal perspective of the artist. Fritsch has repeatedly taken the concrete existence of art within a market economy as her subject matter using techniques and focusing on themes with a specifically public dimension, such as the multiple, consumer goods or the museum itself. In a certain sense each of her works is a work for a public place, that is to say for a place that many different people can share, both physically and mentally.

The Highest Common Denominator

The public dimension of art takes many different forms, depending on the actual site of the work and its theme. While still a student, Fritsch made a series of relatively small sculptures which have an undeniably private quality. Witness, for instance, a model-like chimney stack that seems like a concentrated memory – reduced to a manageable size – of the industrialised landscape of the Rhein-Ruhr region where she grew up. *Schornstein* (*Chimney*, 1979) could be seen as a decorative domestic

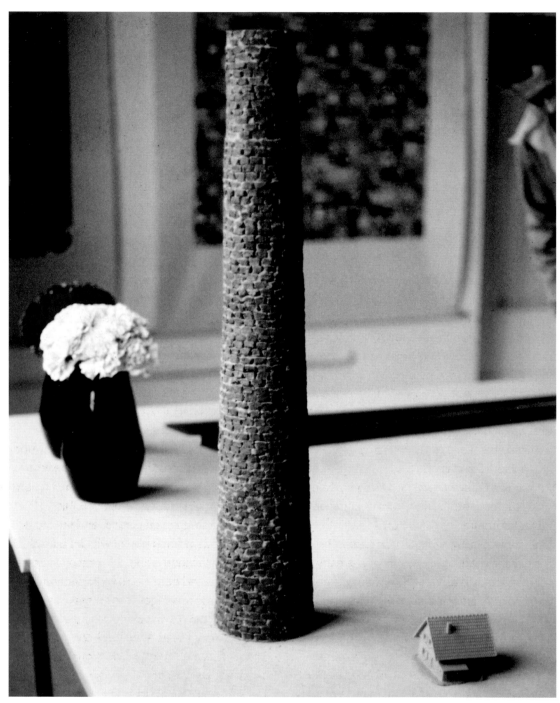

Schornstein (*Chimney*), 1979
Clay, mortar
Diameter 8 cm, height 80 cm
(diameter 3⅛ in, height 31½ in)

item: a portable object that embodies a sentimental relationship. Generally such souvenirs portray unique landmarks like the Eiffel Tower, the Rialto Bridge or the Statue of Liberty. By contrast, Fritsch's chimney takes an everyday symbol of a disappearing culture and presents it as a mundane fetish for all those who connect some part of their identity with that sight. One might even go so far as to say that this is nostalgia being used as a serious form of communication. The function of these small sculptures is seen all the more clearly when they emerge later in Fritsch's *Werbeblatt I (Advertising Leaflet I*, 1981), which was originally intended as a supplement to a New Wave magazine. *Werbeblatt I* took the form of a completely dispassionate sales pitch for items with either a domestic or decorative use. On the one hand, therefore, it could be seen as a young artist's marketing ploy, located somewhere between 'art for all' and 'art as a service provider'. On the other hand, this 'advertisement' is a work in its own right, which takes individual works and turns them into an ensemble, summing up what has been achieved so far.

From this Fritsch developed her own 'sales-speak' rhetoric, exploiting a form of communication that is central to our society in order to place her works in a wider public arena. By the time she graduated, Fritsch was already making her first *Warengestell (Display Stand*, 1979–84), which reiterates the intentions of *Werbeblatt I* both symbolically and in real terms, but within a strictly formalised order and with an underlying general theme. The objects presented in *Warengestell* are in a sense in seductive isolation, seen at one remove due to the cool presence of the tall, glass tower which prevents immediate access to them. This effect is heightened by the fact that what look at first sight like disparate objects, soon suggest chains of associations pointing indirectly to a possible, fairy-tale biography. (A recent companion piece to this work focuses instead on the darker sides of the artist's oeuvre and life.) On the other hand, the *Wühltisch (Bargain Counter)* of 1987/9 celebrates the communicative side of selling in its purest form, and directly addresses our delight in making a choice and a purchase. The three large display stands from the same period – *Warengestell mit Madonnen (Display Stand with Madonnas*, 1987/9), *Warengestell mit Vasen (Display Stand with Vases*, 1987/9) and *Warengestell mit Gehirnen (Display Stand with Brains*, 1989) – are much more ambiguous. In these works the grammatical framework of selling, the stand itself, has receded into the background. Instead its contents have multiplied and we see excessive numbers of single items. A pyramid of vases with an emblem of a ship as a symbol of longing; a double cone of brains representing the pure spirit; impossibly multiplied uniqueness in a tower of Madonnas – our usual images of merchandising are displaced, and the most familiar of items are imbued with an aura all of their own. In these works the idea of an artistic series adopted from modern production processes is no longer taken literally as a way of making items available to all and sundry, but instead emerges as a contradictory yet potent image in its own right. It is as though this image takes notions that already exist in the minds of its viewers, and burns them all the more

deeply into their consciousness. Not as an act of simple confirmation; on the contrary it casts doubt on the smug self-satisfaction of these familiar symbols, and relocates them in a realm of basic contradiction: light–dark, good–bad, this–yet that.

Consumer goods have become the highest common denominator of human interaction and like money – to which Fritsch has devoted a specific group of works – they are completely 'public' in every sense. Fritsch taps into our sub-conscious awareness of this and alludes to it in the sales techniques she employs in her structures. However, these demonstrate not only the ways commercial goods are presented, but also the way her own works are made. In all her work the precision of their realisation is achieved by means of a lengthy manual process, yet the results look deceptively like anonymous, industrial products. Even the most intimate and lively motifs fluctuate between uniqueness and remoteness on the one hand and seriality and availability on the other. So the 'factory finish' of Fritsch's works, which establishes common ground with the viewer, is only half the story. While it is very consciously constructed as a means to mediate the work, it never reaches beyond a purely symbolic level. Indeed, the characteristic feature of these sculptures is precisely this sharply drawn demarcation where the sphere of the everyday and the realm of art meet without ever merging. The difference between the two is not treated as a semantic problem as is the practice with ready-mades, but is rather demonstrated in the phenomenon itself. In terms of the public dimension of the work, this means that even the gestures that come from the world of selling are not intended to blur the division between art and reality, but to create a mid-way zone of heightened collective perception.

In Streets and Squares

In spring 1986 a man of advanced years, dressed in grey, walked through a park in a Dutch town with his white English bulldog. The two had something faintly theatrical about them, as though in the middle of an ordinary day an image leapt into over-sharp focus for just a moment. Their appearance was the enactment of a configuration that was possible, even likely, in a location of that kind. It was so perfect in its form and colour, in its sociological and psychological overtones that, depending on one's perspective, the realism of the sight could easily become pure fiction. Due to certain circumstances, the man and his dog only made a single appearance; a mental photograph of the two has since lodged in the minds of all who saw them.

In works such as *Spaziergänger mit Hund* (*Man Out for a Walk with Dog*, 1986), the parameters of the museum are left behind and the work enters that realm which we usually understand as 'public' in the real sense of the word. It is striking that the entrances Fritsch stages for her work are often relatively fleeting. Most fleeting of all is a moment when one is suddenly aware of a scent in a stairwell, as though someone else had just been there – *Parfüm in Hausflur* (*Perfume in the Hallway*, 1984). The endless ramifications of memory generate an instant interaction between the senses:

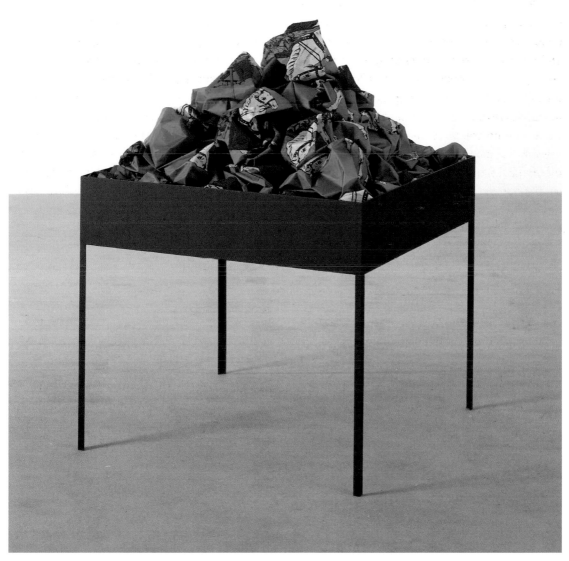

Wühltisch (*Bargain Counter*), 1987/9
Sheet iron, printed silk scarves
90 × 90 × 140 cm (35⁷⁄₁₆ × 35⁷⁄₁₆ × 55⅛ in)

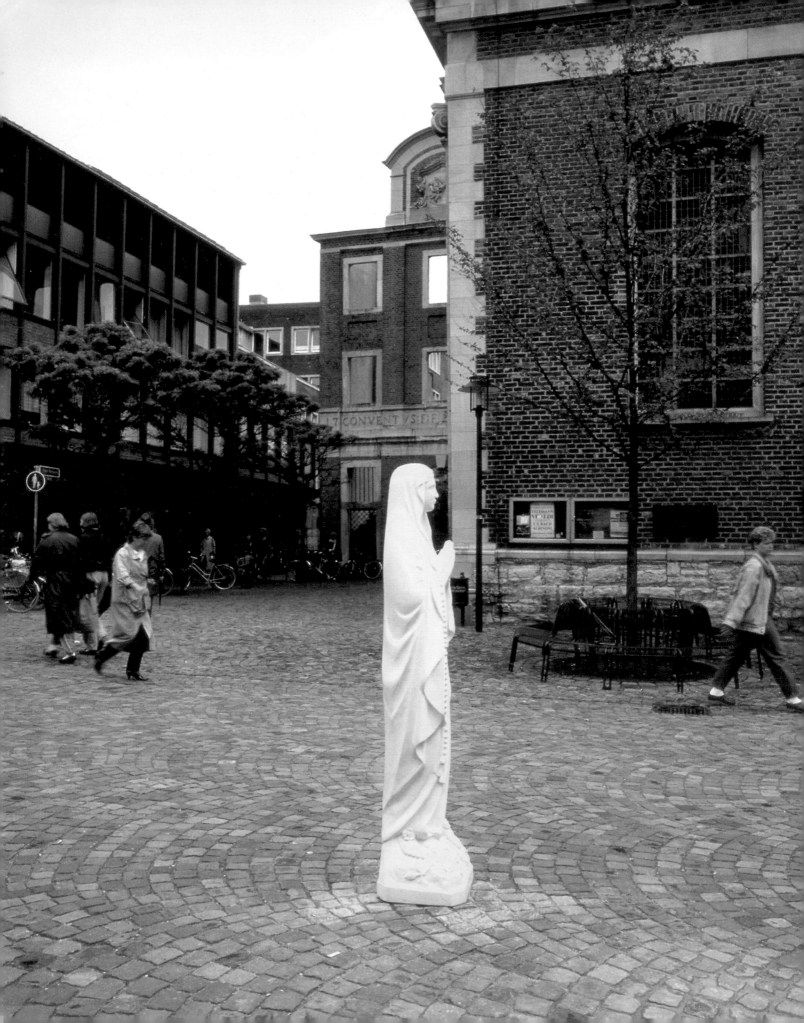

the scent creates a mental image of a figure, a type, even a particular character. Similarly ephemeral, albeit in a different way, is the project *Roter Lastwagen* (*Red Lorry*, 1980/6), involving a red and black lorry that is supposed to drive around endlessly all over Germany. In this case our collective imagination is being addressed, that same imagination we use for publicity stunts for which a particular individual has to be tracked down, or for the myth of the Flying Dutchman. It also provides the confident certainty that major systems of transportation and supply will continue to exist uninterrupted. The constant variability of these works is demonstrated in yet another of Fritsch's works, as yet unrealised, in which foxes – their fur died glowing red – would run around on the green grass of an open-air enclosure.

Yet, for all their dependency on a particular situation, even ephemeral works of this kind clearly set themselves apart from their surroundings. They may focus on moments that are present in reality, but these are then subjected to a process of taking form which uses similarity to accentuate difference. Something akin to this happens in Fritsch's acoustic works. These exist purely as preserved sound, but each work is intended to be heard in a three-dimensional space in which the colour has been adjusted accordingly, and where the sound can properly come into its own. The sounds themselves seem utterly familiar: toads croaking, rain drops, an ambulance siren, the wheel of a water mill, wind howling down a chimney. All of these sounds operate like signals for particular moods which, through one's own experience and not least due to countless references in books and

films, have already detached themselves from the usual acoustic wallpaper of life. When they are encountered in Fritsch's work they are immediately identifiable, yet one is nevertheless unsure whether this is a simple repetition of reality, a form of imitation or a completely new creation. Nature or art? Chance or composition? Thus in the acoustic dimension, which does after all have a particularly high public presence simply because it is difficult to avoid, Fritsch's work once again makes clear distinctions. It arouses our imagination precisely because it swings between reality and fiction, touching those only barely perceptible moments in life when the everyday and the imagination come together in a communicable image.

Fritsch's landscape projects, and particularly

Friedhof für Reihengräber
(*Cemetery with Row Graves*), 1980/2
Ink drawing
80 × 80 cm (31½ × 31½ in)
Project documented as ground plan
and elevation on a scale of 1:400

Madonnenfigur (*Madonna Figure*), 1987
Epoxy resin, paint
40 × 34 × 170 cm (13⅜ × 15¾ × 66¹⁵⁄₁₆ in)

her plans for cemeteries, highlight yet another aspect of the way her works are embedded in the public domain. In *Friedhof für Urnengräber* (*Cemetery for Urn Graves*, 1982–3), the formalised nature of this graveyard and the constant recurrence of the same pattern becomes an impressive image of effortless concentration. The geometry of the burial grounds has a rigour that is unfamiliar, as well as being in some ways an ideal design. Most significant of all is the anonymity of such places of rest and contemplation. Indeed, anonymity is a necessary pre-condition for these places of collective praxis and collective images. Such places may display only a limited measure of individuality in their signatures; they must be doubly expansive images which, rather than dominating the imagination, merely provide a background. The artistic problem is to identify the point where anonymity and a characteristic signature are perfectly balanced.

The glowing yellow *Madonnenfigur* (*Madonna Figure*, 1987) on the paving stones in Münster, slightly less than life-size and placed between a church and a department store, was a public work of just the kind that de Chirico wished for in his text. She stood right in the middle of an everyday space and threw in her lot with the passers-by. Münster is a Catholic bishopric, and in this context the image of the Madonna at prayer is not unfamiliar. As a figure that could be regarded as typical of the locality, she might have been able to hide behind a certain degree of normality had it not been for her abrupt appearance in the midst of the hustle and bustle of daily life, and in particular the way in which she stood out from her surroundings with her extreme and atypical colouration. As a

result the Madonna generated a whole range of reactions: some laid flowers at her feet, others attacked her and, in the end, destroyed her. Both responses show that the sculpture made its mark on a particular stratum of collective ideas, however contradictory, in a situation where images with that level of impact are usually only found in advertising. It had this effect because, like all Fritsch's works, it had a dual relationship with public space: it was integrated into it yet still maintained a certain aura, it brought concrete images to mind yet still remained enigmatic. In all of this there is an undercurrent of provocation, for however much a work may evoke widely entrenched images, it is still about the difference that art makes, about the residue that cannot be accounted for by what we already know.

The Place of the Work of Art

Placing any of these works in a location means displacing something else. Like the *Madonnenfigur* in the shopping street in Münster, the *Messekoje mit vier Figuren* (*Trade Fair Stand with Four Figures*, 1985/6) had an evidently dichotomous relationship with its surroundings at the Cologne Art Fair. In fact this white box is the opposite of a cabin, a kind of anti-cabin. It has no interior for presenting works of art; instead in a sense it has been turned inside out. The whole display becomes the contents of this cabin that exposes on all sides; thus it is open and yet closed. A Minimalist block that one could well take as a commentary on the institution, it stood out rather oddly and unaccountably in the

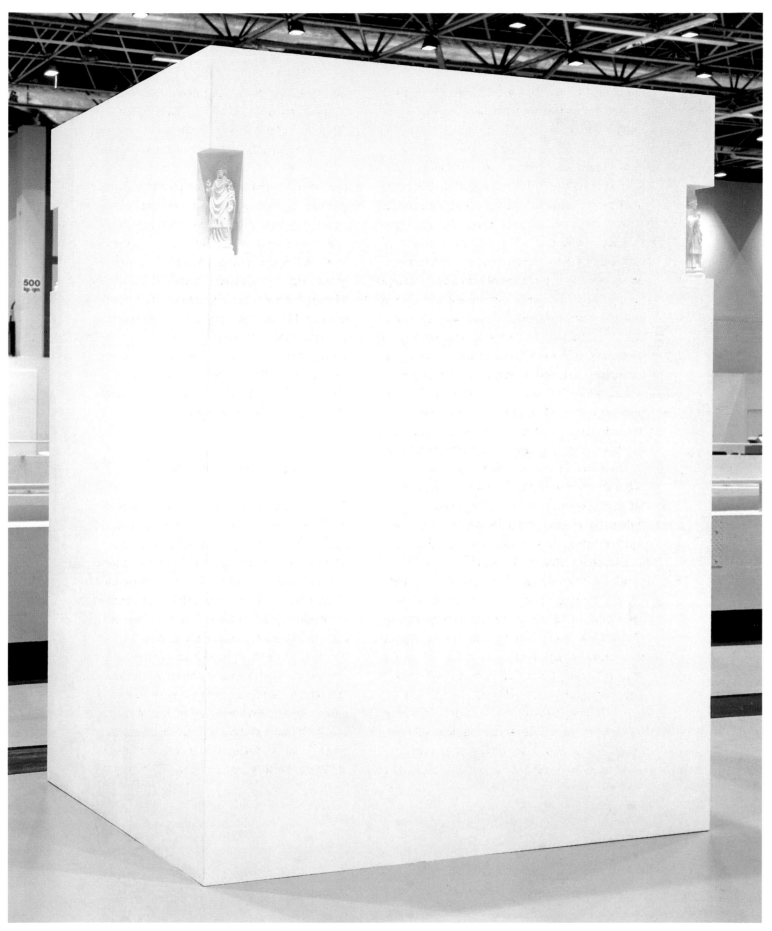

Messekoje mit vier Figuren (***Trade Fair Stand with Four Figures***), 1985/6
Wood, gypseous alabaster paint, plaster of Paris
200 × 200 × 280 cm (78¾ × 78¾ × 110¼ in)

midst of this busy marketplace. Four identical figures of saints stood in little corner niches. For all the reduction of form and colour, it was as though a completely different way of presenting and understanding art had somehow ended up in a wholly commercial milieu. For all its compliance with the partition-wall tactics of an event of this kind, there are overtones of a completely different, holistic relationship between art and architecture of the kind that may still be seen in churches from past ages. The work could even be read as a formalised abbreviation of the traditional interconnection between sculpture and the built space around it. Thus a completely different notion of space is introduced into the arbitrary nature of the places given over to art in an art fair or in a modern, neutral museum space – ironically enough in the form of a white cube

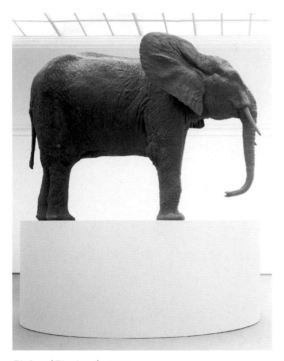

Elefant (*Elephant*), 1987
Polyester, wood, paint
380 × 160 × 420 cm (149⅝ × 63 × 165⅜ in)

turned inside out. The sculpture is as much at home in this context as in a real or mental 'elsewhere'. The box begins to float; the sculpture withdraws behind its smooth, white walls; what is left is poised mid-way between usable object and aesthetic image.

The ambiguous connection between Fritsch's works and the places where they make their mark is one of the pre-conditions for their impact on our collective memory. It is only this combination of presence and absence that gives the images the necessary openness for them to become 'public' property in the sense that they find their way into a mental space shared by countless individuals. One need only call to mind one of the seminal pieces in this artist's oeuvre, *Elefant* (*Elephant*, 1987). This is without doubt an artefact, although initially it is unclear whether it is a work of art by Nature or by a human hand. Entirely in keeping with museum practice, the precise geometry of the pale plinth sets the object apart, at a suitable distance for it to be duly observed and wondered at. This mode of presentation for unusual, and hence rare and precious, objects goes back a long way. Today it is primarily found in the museum context, even if presentations of commercial products often imitate it in the hope of implying a certain level of value. In that sense *Elefant*, with its domesticated exoticism, serves as an image of museums and all they represent, indeed in a way the work reflects the institution itself. At the same time it is impossible to ignore the fact that this is an animal. The true-to-life finish of the dermoplastic from which the sculpture is made reminds us of the very different origins of the object itself: not just some natural

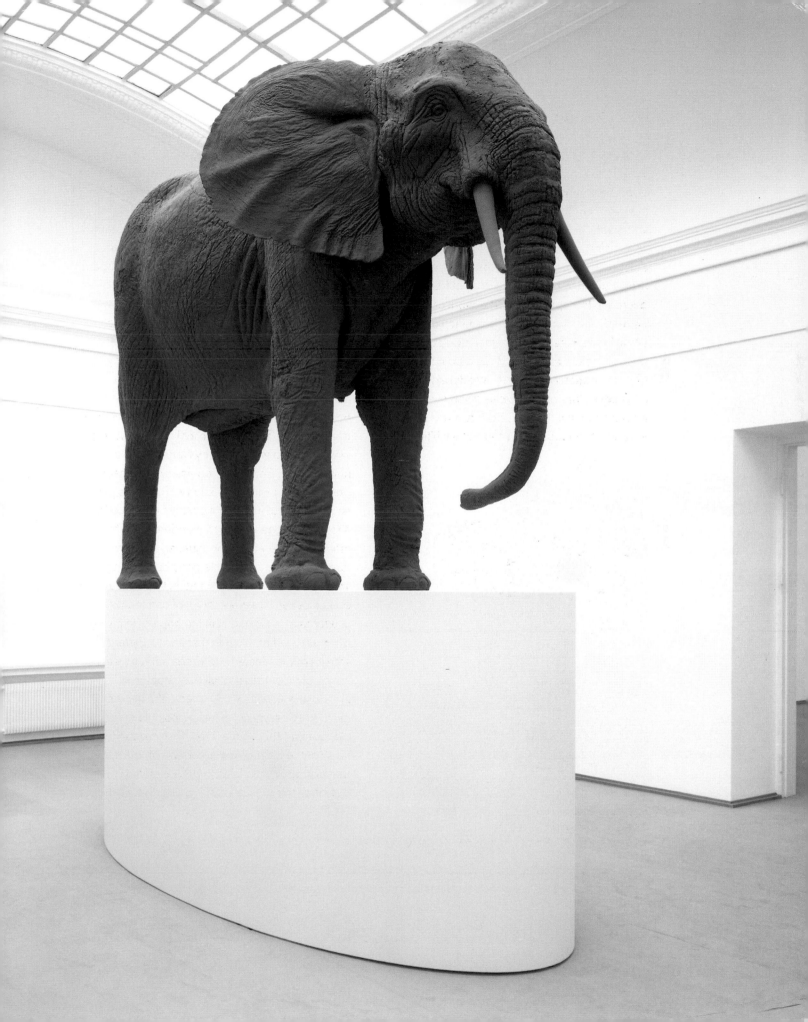

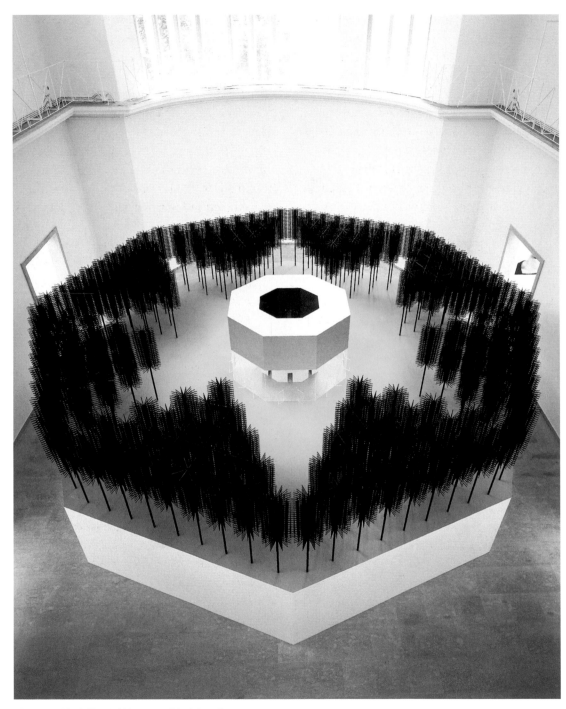

Museum, Modell 1:10 (*Museum, Model 1:10*), 1995
Wood, aluminium, Plexiglas, foil, paint
1040 × 1040 × 330 cm (409⁷⁄₁₆ × 409⁷⁄₁₆ × 129¹⁵⁄₁₆ in)

history museum (these days strictly separate from the art museum) but, even further back, the real and mythical habitat of the creature itself. Paradoxically, it is not least the viewer's perspective from below and the green colour of the elephant that suggest this other place. These characteristics raise the image up into the realm of the imagination where it finds an anchor, thanks to the productive input of the viewer. The figure of the elephant thus takes on the function of a narrative framework, with room for very different stories: tales of majesty, intelligence, age, memory and of the affinity or the distance between animals and human beings.

In one of her works Fritsch has focused specifically on the conventional venue for art, the museum itself. But right from the outset she blurs the actual dimensions of the image: the scale she chooses implies something between the substitute function of a model and the physical reality of a sculpture. Thus *Museum, Modell 1:10* (*Museum, Model 1:10*, 1995) leaves our thoughts relatively free to manoeuvre within the realm of the possible. As a statement with art-political implications, the work is polemical and declamatory, but its qualities as a sculpture quickly relieve it of any such apparent lack of ambiguity. This 'museum' is a double art cell for images and sculpture, and is separated from everything else by a sharply delineated protective zone of trees. As a place it would not be inaccessible, but it would require a conscious decision to accept the rules laid down: namely that there should be an intense encounter with no more than a very few works in suitable surroundings. In Fritsch's own words, this is a 'place of sudden reversal', that is to say a place that makes the highest demands, which are themselves not only of an aesthetic nature. Here, Fritsch explains, one should be able to experience 'the strangeness and melancholy of things through the absolute nature of the artistic decision in the face of the inexpressibility and foundationlessness of existence'. This presupposes a high level of concentration on all sides, and in connection to this Fritsch refers to 'the notion of art being limited to work that is both committed and of a high pictorial quality'. Even if the artist intends that this vision of a museum should be seen only as one possibility among many, this work – which we cannot separate from the commentary it offers – still seems like an alien and contrary intruder in its own time.

Museum, Modell 1:10 once again clearly demonstrates the notion of 'public' in Fritsch's work. On the one hand it applies to a place where a work of art may be seen in a fitting manner and where it may induce intense responses. On the other hand, the public quality of a work is something that the viewer must consciously seek out: something that is not necessarily present simply by virtue of the way a venue is designed, but which viewers must create themselves by engaging with the work. The construct of the 'public' in the arena of the image is the actual location of Katharina Fritsch's work. But a 'public' dimension of this kind can only result from the uninterrupted interaction of openness and artistic generosity on one side and a deeply personal response and recognition on the other. On the interface of the image, the breadth and multiplicity of the collective imagination meet the precision and binding nature of the individual decision.

1 Giorgio de Chirico quoted by Katharina Fritsch in *Parkett*, Zurich, issue 25, 1990

Translated from the German by Fiona Elliott

Men and Mortality

Iwona Blazwick

'*To become a man must be finally to attain the solidity and self-containment of an object.*'[1]

With the exception of a yellow Madonna – a goddess whose status rests anyway on being the virgin mother of a male god – Katharina Fritsch's sculptures of the human body have all been male. Her larger-than-life, three-dimensional figures reference the formal vocabulary of the statue. Yet they do not stand on plinths; Fritsch's men share the ground that we walk on, the spaces we occupy. Neither are they heroic. These men do normal things – walk in the park, sit at the table, sleep; sometimes they just stand. They do not make expressionistic gestures. In fact they seem completely hermetic, closed off; they are both of our world and external to it. It is true that they trigger the jolt of anthropomorphic recognition; yet the experience of Fritsch's figures is one which hovers between familiarity and the mesmeric fascination of a profound otherness. They go further; their sharp presence intimates a symbolic zone resonant of dark things: the unconscious, the ghost, mortality.

By making figurative sculpture Fritsch takes her place in an aesthetic tradition that is as old as art itself, a tradition in which women were subject to the authoritative gaze of men. She turns the tables on the history of figuration by virtue of being a woman making images of men. Fritsch also incorporates the sculptural revolutions of post-war movements such as Minimalism, Pop and Conceptual art and Arte Povera, their privileging of '… the vernacular and the commonplace, the assertion of the physical (as opposed to the metaphysical) and the serial (as opposed to the singular) combined with a merging of the distinction between abstraction and representation'.[2]

Our encounter with Fritsch's sculpture is first as an image. She uses matt, saturated colour, evenly distributed and sharply delineated, with no naturalistic or expressive modulation of tone. Her palette is restricted and tends to the graphic – red, yellow, black – like the colours in a pack of cards. These graphic qualities give the visual aspect of Fritsch's sculpture the potency of a sign – they seem to imprint themselves onto our consciousness, apparently correspondent with something that is already there. Fritsch's figures appear to be emblematic – but of what?

Beyond the first, optical impact, the scale and materiality of her figures exerts a powerful phenomenological presence; even her single figures generate a palpable environment. But, unlike the conscious theatricality of much installation art which may transport the viewer into another imaginative space, these environments have a realism that

situates the viewer in the here and now, that heightens their experience of where they are. At the same time, her subject-matter has an erstwhile familiarity which triggers a sense of something remembered.

Fritsch's sculpture is literal in a way that recalls the hallmarks of Minimalism; she creates figures, but they are also objects in their own right. Her works are indeed a combination of representation and abstraction. In two instances they have comprised living people, but 'articulated' by her own vision. Her contribution to Sonsbeek '86, a large outdoor sculpture project in Arnheim, was both site specific and performative. For *Spaziergänger mit Hund* she hired an elderly gentleman to walk an English bulldog (also hired) around the local sculpture park – what could be more typical, more true to the context of the site? At the same time both were dressed by the artist and followed her instructions: the red stars on the dog's collar, the perfect suit of his walker, set them slightly apart in a world of their own. By triggering a sense of the familiar, indeed of shared or collective memory, Fritsch is able to generate a simultaneous experience of oneness combined with otherness. This experience of the work is achieved in part by using the male figure. 'Just as men used to paint women in earlier times, I am interested in depicting men. It's the otherness, foreignness.'[3]

Fritsch's second 'living sculpture' also provides another unlikely link to Minimal and Conceptual art in its use of seriality. Her series however, are either found in nature or relate to the notion of the prototype and to mass production. In a work from 1985 titled *Schwarzer Tisch mit eineiigen Zwillingen* (*Black Table with Identical Twins*), twin brothers, each the reflection of the other, sit at a modest, round dining table waiting for a meal. Herrs Wiegmann and Wiegmann look pleasantly unremarkable except in their uncanny resemblance; they are at once singular and generic. The image of the brothers is echoed in the pattern of the tableware, also conceived and created by the artist. The cups and saucers are identical and, we assume, mass produced; each carries the motif of identical twins sitting at a modest round dining table laid with tableware which carries the pattern of identical twins and so on, in endless refraction. The German word 'doppelgänger' can mean both 'a double' and 'a wraith'. To see a unique self doubled is to undergo a complex but simultaneous sensation of disbelief, wonder and subtle fear; our sense of individual identity is momentarily challenged. Furthermore, the image of the brothers becomes a pretty pattern which decorates crockery, vessels of the domestic realm so often associated with the feminine.

This strategy of repetition comes breathtakingly to the fore with *Tischgesellschaft* (*Company at Table*, 1988) where thirty-two identical men are seated on benches on either side of a long table. Their eyes are 'blind' in the manner of Greek statuary. They are slightly

Geschirr (*Tableware*), 1985
Polystyrene, paint
Prototype

hunched over the table, their hands placed in front of them. The exact repetition of each figure's crisp black hairline, facial profile and body silhouette subsumes each individual into an overall design. The startling resemblance between each man combines with their multiplication to generate a sense of awe in the face of an intimated infinity. The relentless nature of this excess, its inevitability, moves affect from exhilaration to oppression, towards something, in the artist's own words, nightmarish. The austerity of the figures' black outfits and the stark contrast between their black hair and white bodies is juxtaposed against an equally precise, yet vividly patterned tablecloth. Like a composite of traditional embroidery stitches, peasant fabrics, flags and early computer games, this scarlet and white design seems to incorporate all patterns. The hands of the figures are placed on the cloth and become part of its continuity.

It is interesting to note that the fact that this company is made up solely of men is rarely commented upon. Could this be because it is unconsciously accepted as a normative social construction? From history painting to contemporary film and photography, it is men who represent social protagonists. Even at the beginning of the twenty-first century

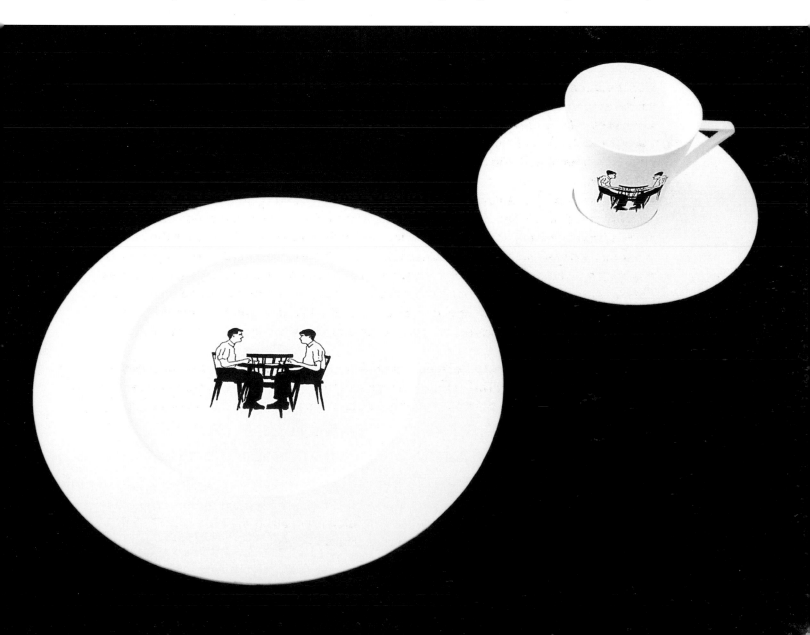

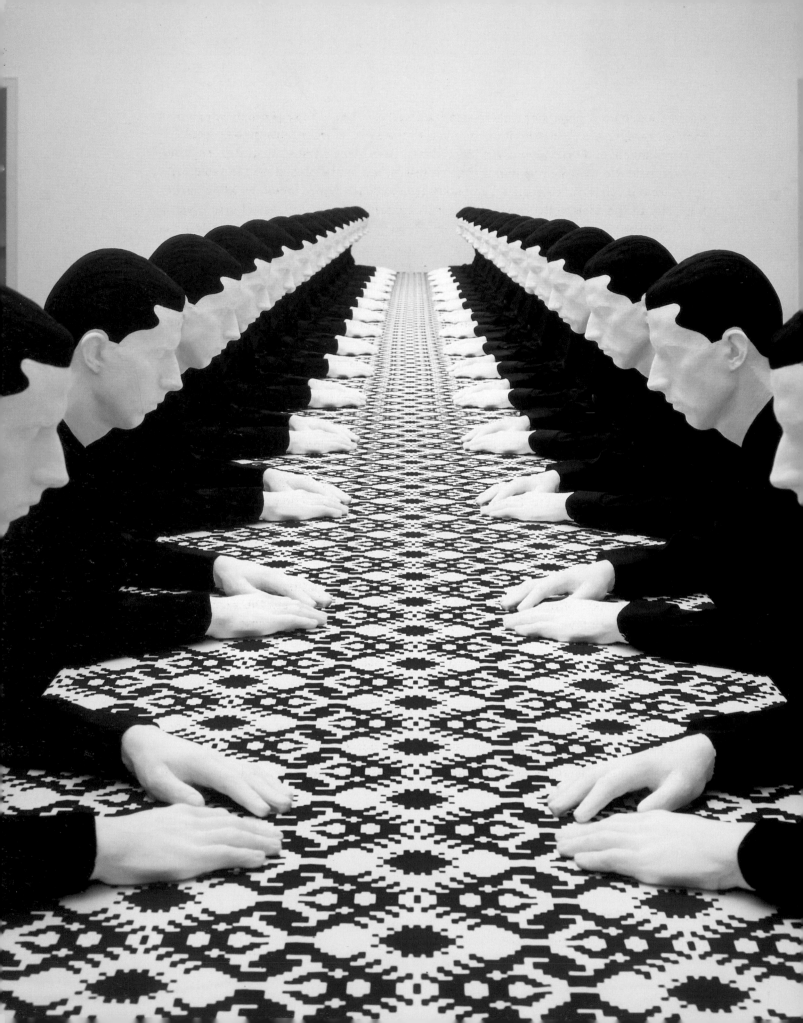

a group exhibition comprising only men is regarded as normal; a list of artists who are all female however, earns an exhibition the reductive nomenclature of 'a women's show'.

The identical outfits of the men in *Tischgesellschaft* imply a fraternity which may even be monastic. No food seems imminent; the men's hands are placed on the table, as if ready for a discussion, perhaps a combative one. Yet each figure looks not at his neighbour, but at the tablecloth, apparently lost in thought, in company, yet alone. There is an emblematic quality to this installation which suggests a symbolic register. While the title speaks of conviviality, the production-line quality of the work implies a Marxist conception of alienated labour. However, other readings suggest themselves; might we think of this enigmatic work as symbolic of all those social structures across time and place, the boards, councils, governing bodies, juries, secret societies, despotic regimes and democratic parliaments, that have been the exclusive and vehemently defended domain of the male?

Or might we understand this as an expression of an intense solipsism, an evocation of the myth of masculinity as being strong in silence, independence, freedom from domestic ties, from relationships, from language itself? In an article on masculinity and the genre of the Western, the cultural historian Jane Tompkins writes,

> 'To speak is literally to open the body to penetration by opening an orifice; it is also to mingle the body's substance with the substance of what is outside itself ... it suggests a certain incompleteness, a need to be in relation ... The interdict masculinity imposes on speech arises from the desire for complete objectivisation. And this means being conscious of nothing, not knowing that one has a self, not knowing that one is separate from the world. To be a man is not only to be monolithic, silent, mysterious, impenetrable as a desert butte, it is to *be* the world.'[4]

We could also interpret something redemptive from this awe-inspiring work. The singular, isolated state of each member of this company also suggests the possibility of contemplation or prayer. The critic Carolyn Christov-Bakargiev has commented that the white, impassive faces of the men are given a faint pink glow by the reflection of the vivid scarlet of the patterned cloth. Christov-Bakargiev positions this work at a turning point within the ethos of postmodernism prevalent in the late 1980s:

> 'There seems to be the need to reformulate a new subjectivity, and there comes to be a questioning of the more cynical postmodern thought, the need for at least an image of a society no longer alienated from labour and direct contact with things.'[5]

As with all Fritsch's work, *Tischgesellschaft* combines the emblematic with the enigmatic, yielding and resisting interpretation.

Tischgesellschaft (*Company at Table*), 1988
Polyester, wood, cotton, paint
1600 × 175 × 150 cm (629^{15}/$_{16}$ × 68^7/$_8$ × 59 in)

Like other European artists who emerged towards the end of the 1990s and who owe a debt to Pop art and Arte Povera, Fritsch incorporates 'the real' by creating objects which already exist and function in the world on an everyday yet universal level, such as a table or a bed. While sharing the language of craft and function, these objects are nonetheless made by the artist. They are both furniture and sculpture. They are real, but to cite the Minimalist sculptor Donald Judd, 'specific' objects. Yet, inevitably, they locate the work in associative realms – a table may signify domesticity, nourishment, conversation, decision making, ritual, sociability, work. In relation to the table, the body is upright, yet seated; it is also given over to an act – eating, communication, labour. A bed carries the connotations of sleep, sex, illness and death. Here the body is horizontal and therefore vulnerable, passive, no longer in a controlling position. These objects speak of the most fundamental aspects of human existence. In this they are signifiers of the real, objects which abide through time, across all societies; at the same time they symbolise the cycle of existence from birth to death.

Fritsch harnesses material, phenomenal realism, not only to the realm of the symbolic, but also to the unconscious. *Mann und Maus* (*Man and Mouse*, 1991–2) swoops up the symbolist nightmares of Francisco Goya, Henri Fuseli or Odilon Redon and makes them physically manifest with cartoon-like brio. A sleeper, the very same man who sits at the table, has been mounted by a giant and statuesque mouse, an incarnation of cuteness transformed into an immense contemporary incubus. The work was conceived as a wryly melancholic take on the unrequited nature of contemporary love:

> ' ... the whole image has something to do with ... failed relationships involving love. Often men are very passive in this respect, and women very active – and women suffer from the men's passivity. That is of course an unfortunate aspect of our society; the men withdraw increasingly, and the whole thing is funny in a sad sort of way. The man lies in bed, awake, with his eyes closed: I am white and innocent and I'm also not making an effort ... The poor, heavy, fat mouse is sitting on him with its little eyes open, wide awake and could actually crush him to bits, but it doesn't want to ... that is an image of a completely unbalanced relationship in which two people are missing each other completely ... '[6]

The effect of this elegant yet bizarre formal juxtaposition – a dense vertical mass pushing down on a 'soft' horizontal plane, light-absorbing blackness contrasted with a reflective white, the bestial conjoined with the human, makes you jump and then laugh; it generates an anxious hilarity which in itself masks a kind of horror.

In his essay *The Uncanny* of 1919, Freud connects the dread triggered by certain kinds of spaces or situations (and recounted through the narratives of myths, fairy tales and

Mann und Maus (*Man and Mouse*), 1991–2
Polyester, paint
225 × 130 × 240 cm (88⁹⁄₁₆ × 51³⁄₁₆ × 94½ in)

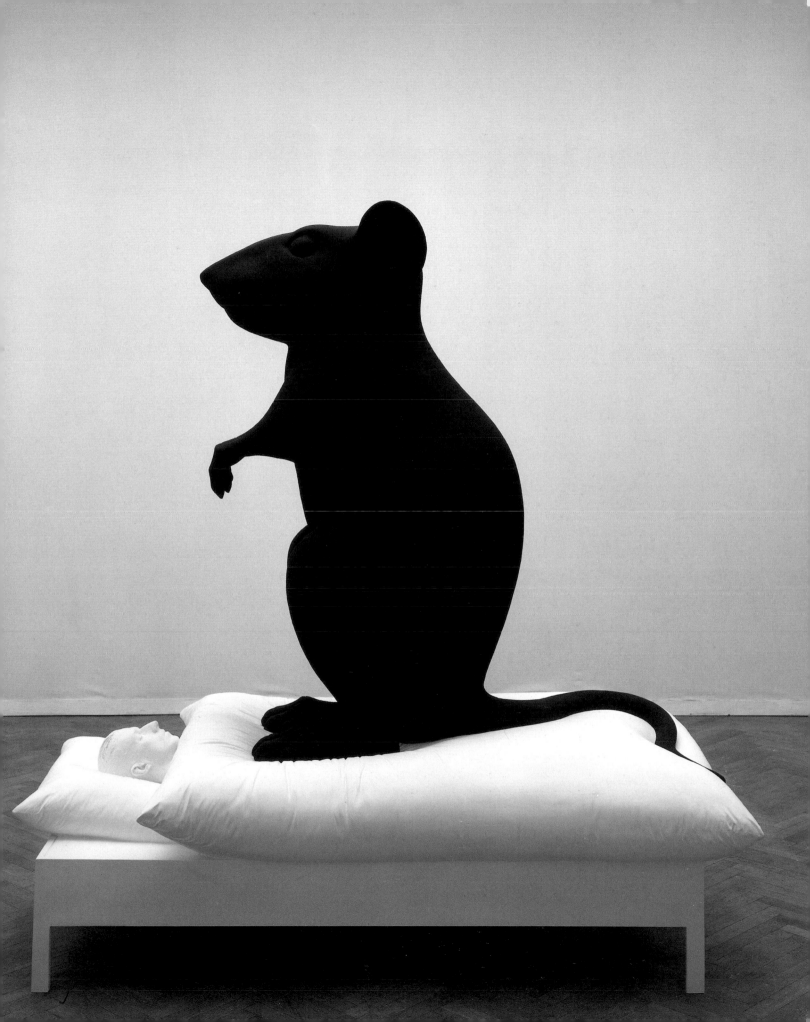

horror stories), with the return of the repressed: sexual drives, incest, the trauma of witnessing violence, the death wish. Fritsch's choice of a mouse taps a typical phobia symptomatic of repression – fear of rodents. The work's dramatic magnification also perfectly illustrates the transformation at dead of night of a small anxiety into a monstrous presence, a psychological dead weight that we all know so well. The cosy, crisp white duvet becomes a form of entombment. The man underneath is also white. His face is both a depiction of sleep and a death mask. This work also encapsulates the beguiling innocence of much of Fritsch's subject matter – the 'mousie' as she calls it, elsewhere poodles, a baby, a lexicon of fairy stories; and underneath a deep, Goya-like darkness.

Just as the simple lilting rhythms, sing-song repetitions and addresses to children belie the macabre content of nursery rhymes, so the 'Dance of Death', an allegorical genre, portrays our journey to mortality in the form of a jaunty parade. Its origins lie in European medieval art, yet arguably it has persisted, particularly in German visual culture, to modern times.[7] Typically leading a parade of dancing figures representing rich and poor, young and old, good and bad, Death is presented as a prancing, charismatic presence, the original and timeless Pied Piper. He has danced his way through the sixteenth-century stone friezes of Christoph Walther, the etchings of Albrecht Dürer and Hans Holbein, the nineteenth-century engravings of Alfred Rethel, the twentieth-century paintings of Max Beckmann and photographs of Richard Peters, right here into the twenty-first century. Death, the gendered skeleton, always unquestionably male, has taken his place among a trinity of 'bad men' created by Fritsch.

Doktor (*Doctor*, 1999) continues the characterisation of Death as essentially Faustian; he offers the paradoxical possibility of cheating mortality. From the feet up, this dazzling white figure is instantly recognisable in his thick soled, comfortable shoes, his neatly pressed trousers and surgeon's coat. The figure's pure, radiating whiteness speaks of hygiene. There is something strange about the torso; it looms up like a column towards almost poignantly narrow shoulders and there, hanging at the end of its sleeves are not hands, but the bones of a skeleton. The *Doktor*'s grinning skull is Death's own head, the classic memento mori. The luminous quality of the work suggests the idea of the doctor as a figure of the Enlightenment, cool, calm, illuminating the world through science. Under his steady hands the body will be cut open, investigated and categorised with the polished instruments of dissection and measurement. This figure stands slightly taller than us; although it reflects our own bodies, it is not only larger than life but free of all our fallibilities, our sweating, abject mortality. Radiating a brilliant but clinical aura, *Doktor* evokes the almost shamanistic status of the modern doctor, the invasive techniques of western medicine and the increasing technologisation and alienation of the body, particularly the female body.

Mönch (*Monk*, 1999) is similarly spellbinding, emanating what can only be described as a negative aura. Again nearly two metres high, its scale makes our intuitive relation to it one of both recognition and recoil. Here an art-historical thread leads back to Caspar David Friedrich's monk as the embodiment of the sublime: he stands subsumed within nature, looking out towards the horizon with all its intimations of the infinite.[8] For the Pre-Raphaelites or the Symbolists, the monk's cowled body becomes a cypher for transcendence, for passage through mortality to eternal life. Fritsch's figure is covered in matt, black pigment that is so dense and unreflective that it appears to suck in light. The symmetrical, almost architectural proportions of the figure also recall gothic statuary which in its extruded forms and celestial gaze emphasised the soaring architectonics of

6. Serie Volksfeste: Lexikonzeichnung Schüzenfest
(*6th Series Public Festivals: Lexicon Drawing Shooting Match*), 1996 (detail)
Silkscreen prints, paper, wood, foil
4 framed silkscreen prints
64 × 74 × 2 cm each (25³/₁₆ × 29¹⁵/₁₆ × ¹³/₁₆ in each)

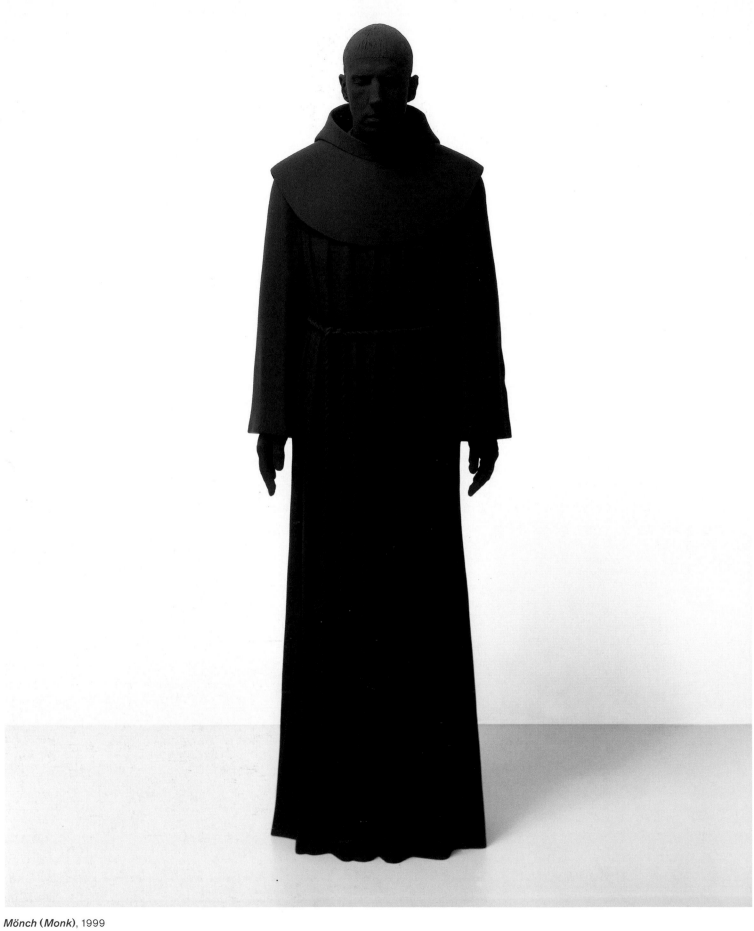

Mönch (Monk), 1999
Polyester, paint
46 × 63 × 192 cm (18⅛ × 24⅞ × 75½ in)

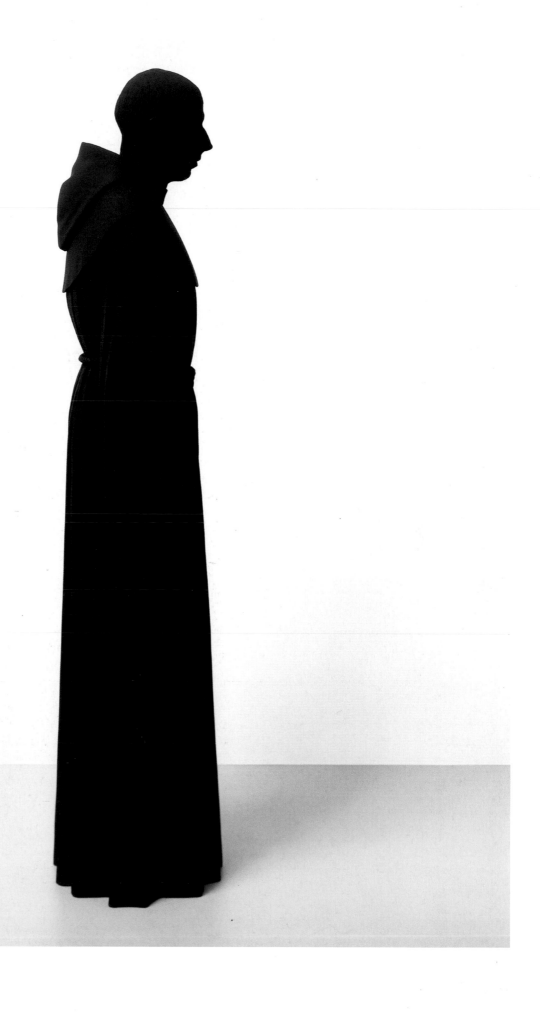

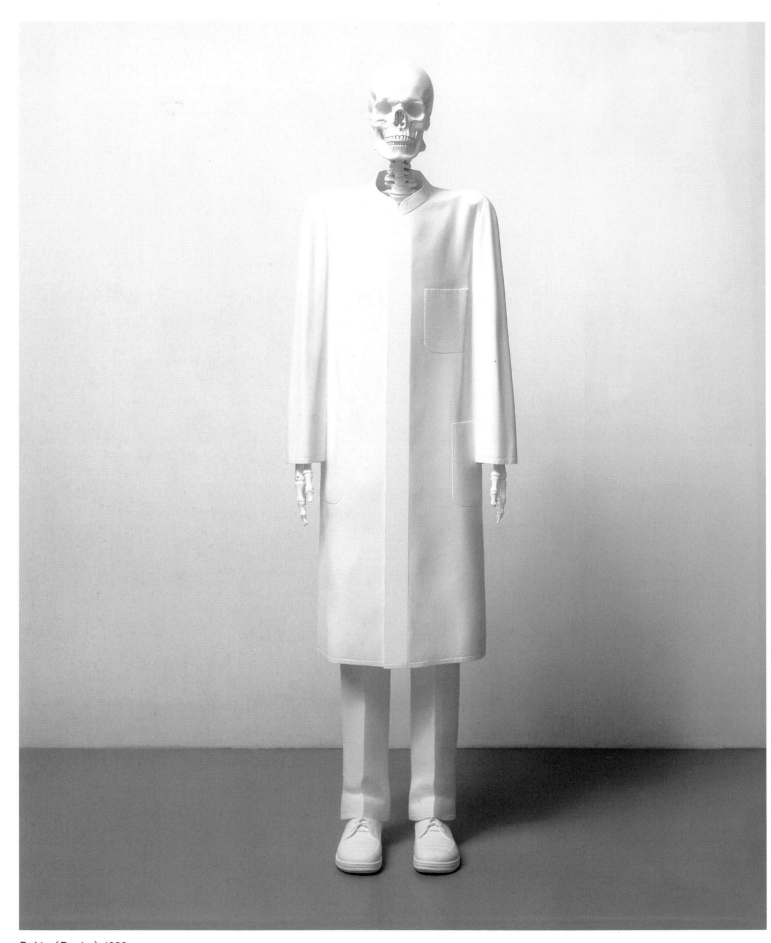

Doktor (Doctor), 1999
Polyester, paint
37 × 56 × 192 cm (14½ × 22 × 75½ in)

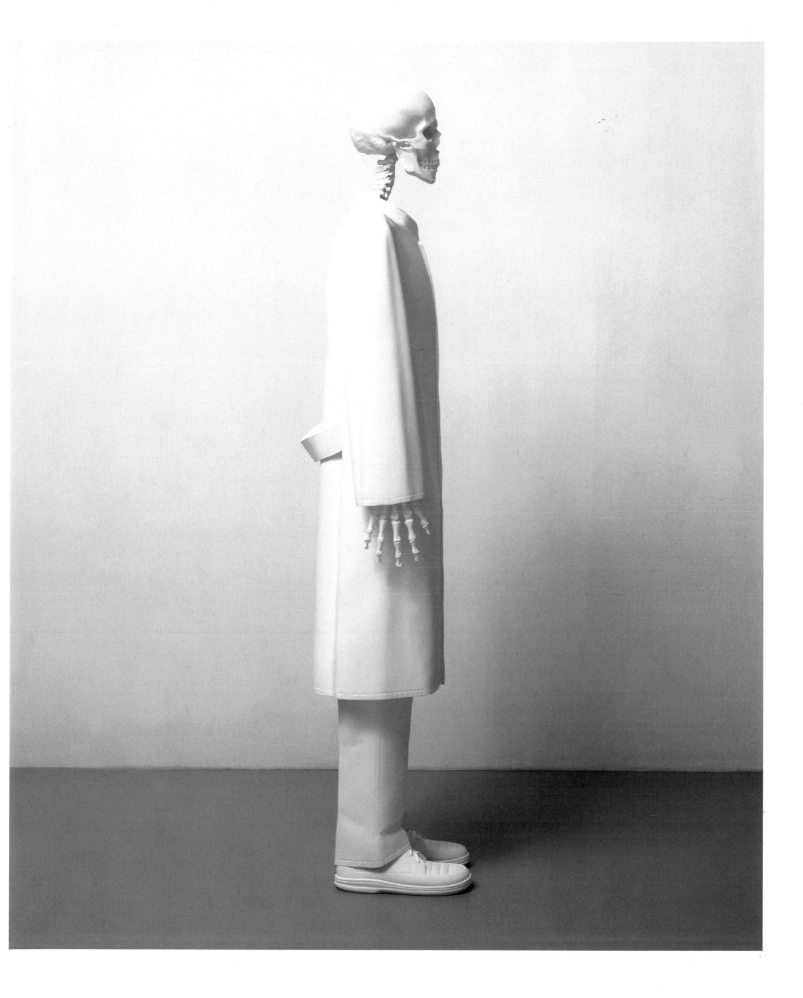

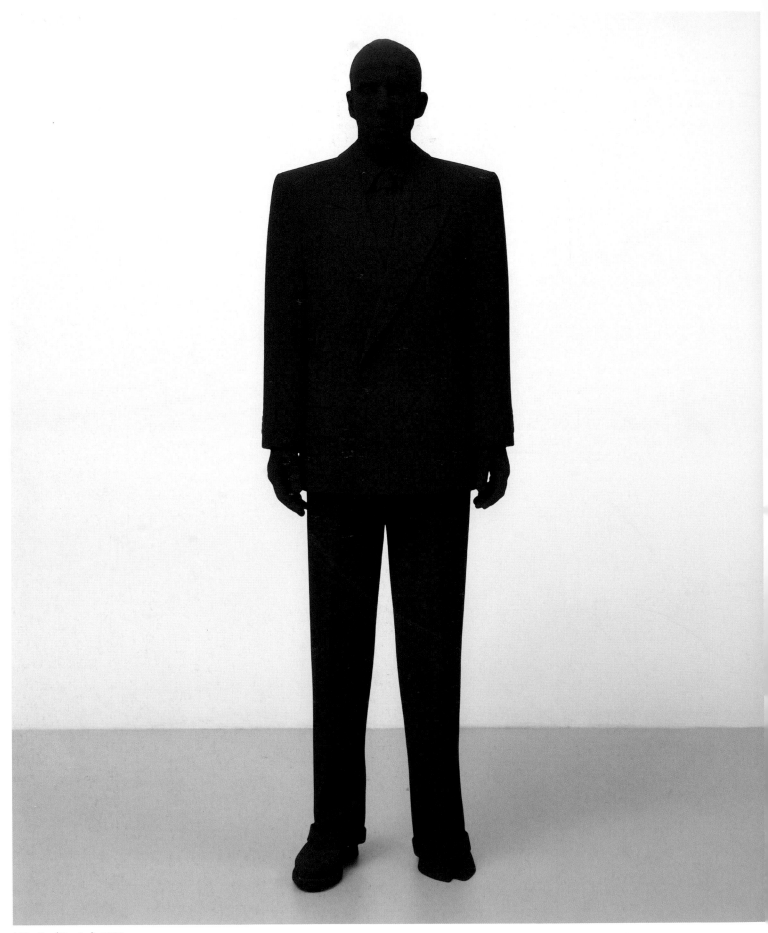

*Händler (**Dealer**)*, 2001
Polyester, paint
40 × 59 × 192 cm (15¾ × 23¼ × 75 in)

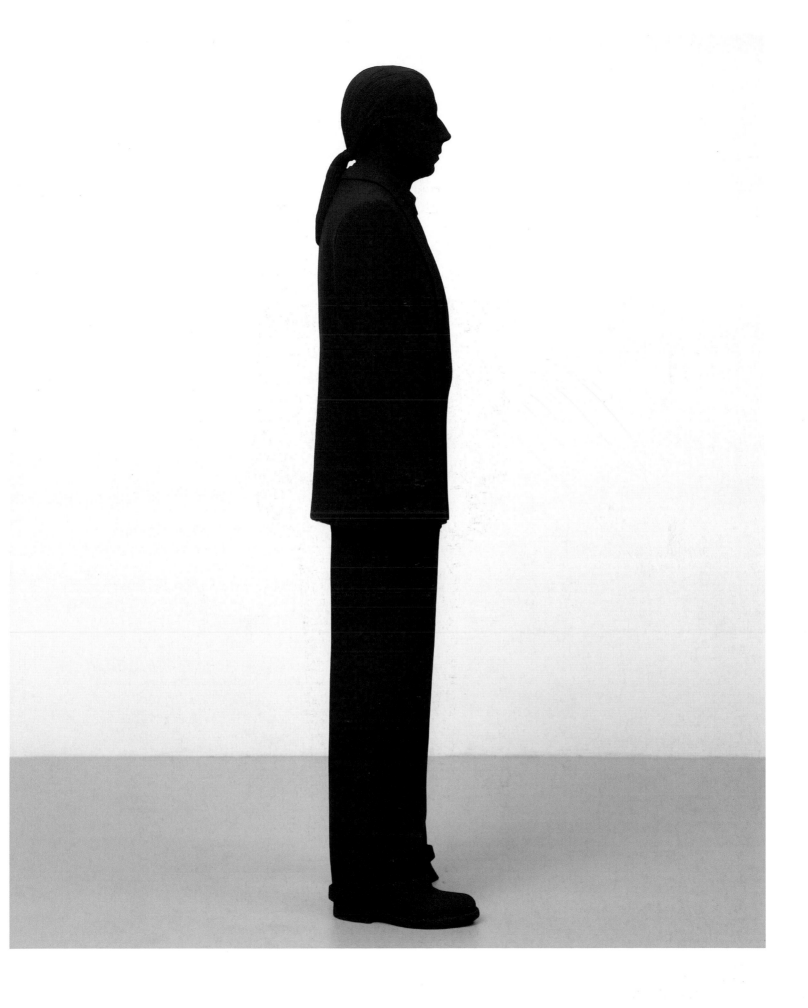

the cathedrals for which it was conceived. It intimated escape heavenwards from the hardships of daily existence and at the same time iterated the presence of an all-seeing divinity. By contrast, the visual effect of Fritsch's singular work is something like a black hole in space, a vacuum which entraps the gaze. While its columnar, upward dynamic matches the transcendental thrust of the gothic, its blackness negates it. Another orthodoxy is evoked, another system of belief: religion, entrancingly arcane, at once redemptive and damning, ineffable, Manichean. The extraordinary, vortex-like pull of the work becomes an analogy for the mesmeric charisma of the shaman, be he religious or, in our increasingly secular society, artistic – we need only think of the acolytes who gathered around artists like Joseph Beuys. Like medicine, religion is also a realm which is organised around the supremacy of the masculine. Hermeticism, celibacy and self-denial are all qualities to be aspired to; obeisance is to the omnipotent father.

The last figure in this unholy trinity is the *Händler* (*Dealer*, 2001) whose presence has been intimated all along in Fritsch's money chests and glittering coin hearts. The *Händler* encapsulates all the magic, the promise and the chicanery of the alchemist; we need to believe that he can turn base metal into gold. He is a composite of the fortune-teller, the croupier, the drug pedlar, the wily politician, the marketing man and of course the art dealer. Writing about the psychological imperatives behind collecting, social psychologist

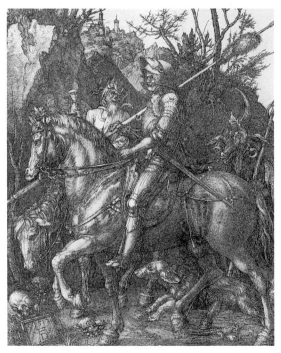

Albrecht Dürer
Knight, Death and the Devil, 1513

Werner Muensterberger observes that 'the relationship between collector and dealer is different from any customary buyer-seller contract because of an apparently more complex interplay, largely due to the intrinsic power that accrues to the dispenser of magic provisions'.[9] The client seeks out the seductions and tantalising feints of the dealer as he does not aspire to completeness, and takes as much pleasure in hunting down the object as in owning it. Fritsch imprints the dealer's image into our consciousness by making him ruby red; the quintessence of rascal heroes from the king of hearts to the scarlet pimpernel, his glow is as crimson as fresh blood. His suit, tie and pony-tail are all part of the universally recognised uniform of the entrepreneur. But on closer

FRIEDHOF FÜR URNENGRÄBER AUFRISS MASSTAB 1 : 200

Friedhof für Urnengräber (*Cemetery for Urn Graves*), 1982–3
Ink drawing
80 × 80 cm (31½ × 31½ in)
Project documented as ground plan
and elevation on a scale of 1:200

examination he is also revealed as having a cloven hoof. The dealer's satanic attributes link him and his two companions to Dürer's *Knight, Death and the Devil* of 1513. Dürer's knight has attracted two opposing interpretations – as the Christian knight, unafraid of death and resistent to the Devil's temptations; or as a robber-baron who walks with Death and the Devil. Fritsch intimates a genealogy back to this allegory locating her three figures within a narrative continuity; yet she resists literal definition. If we can broadly understand this triumvirate to represent religion, medicine and capital, Fritsch wryly acknowledges the possibilities of both negative and affirmative readings. The city of Frankfurt used the image of the *Mönch* to celebrate 2001 as the year of religion.

The scale, profound retinal impact and deployment in space of these three sculptures gives them an overwhelming material presence. At the same time they have a spectral quality, hovering in our consciousness, exerting a magnetic pull that leads symbolically only to death. If we follow this Dance of Death to its inevitable destination however, we find a surprising resting place.

Fritsch has conceived plans for two cemeteries. Her designs are neither sentimental nor morbid. She uses pattern and symmetry to evoke the harmony of order. Like the great earthworks of Walter De Maria, Michael Heizer and Robert Smithson, these proposals occupy a territory between landscape and architecture, follow the logic of geometry and have precise technical instructions:

> '*Friedhof für Reihengräber* (*Cemetery with Row Graves*, 1980/2) is drawn as a ground plan and an elevation and can be implemented as follows: four asphalted paths with anonymous graves and egg shaped bushes are brought together in a Greek key pattern in a square with sides intended to be 200 yards long. The graves are planted with grass and should be placed to the right and left of the asphalted paths, which run to a cruciform center from the north, south, east and west. From there they again lead to one of the points of the compass. Between the graves the strips, $4\frac{3}{8}$ yards wide, are densely planted with rowan bushes, which bear orange berries in the summer.'[10]

As an unrealised project, the location of this cemetery is as yet unspecified, but its co-ordinates are laid down as cardinal points on the compass – it is therefore very precisely situated wherever it might ultimately be realised. With all the rationalisations of an Elizabethan knot garden, Fritsch's cemetery truly signifies the erasure of individuality in the serene logic of geometry. At the same time it offers a restrained collective renewal in the orange berries of the rowan bushes. The *Friedhof für Urnengräber* iterates Fritsch's use of eight as a numerical formula in her work (as with her eight-pointed star, her eight-part key-ring), also to be found in music (the octave) and science (the law of octaves, meaning the relationship between the elements according to their atomic weight) and

architecture (the octagon). Curator Theodora Vischer observes that the structure of Fritsch's work is

> 'characterised by simple rules of order and basic stereometric forms. They are all based on the order of symmetry and the basic shape of the circle. They produce closed bodies and systems both outward and inward, which refer to and reflect themselves. No temporal movement with a beginning and an end develops within them; on the contrary, they have an eerie tendency to cancel themselves out or to repeat themselves ad infinitum.'[11]

The octagonal shape of the *Friedhof für Urnengräber* allows it to grow simultaneously as both a triangular and circular form; similarly the *Friedhof für Reihengräber* expands as both a square and a spiral. Both are open-ended and potentially infinite, intimating boundlessness rather than closure. These exquisitely precise architectural renderings are both utopian and dystopian. In the perfection of order lie both harmony and death; the ultimate non-place is truly found in the graveyard.

Creating non-expressionistic, normative protagonists that in their duplication have the neutrality of a prototype, Fritsch intimates that her figures are emblematic – indeed she has spoken both of her interest in mythologies and in the specific myths of masculinity. 'I think it does have to do with being interested in men, to see through and to understand their role-playing.'[12] Her male figures generate sensations that ricochet between awe and dread, seduction and denial; the portrayal of masculinity in terms of a relentless order and hermeticism shows how its self-perpetuated fictions equal the denial of life. At the same time the uncanny quality of their material presence propels them into an autonomous zone which resists interpretation, leaving them poised between revelation and enigma.

1 Peter Schwenger, *Phallic Critiques: Masculinity and Twentieth-Century Literature*, London, 1984, p.54

2 Iwona Blazwick, James Lingwood, Andrea Schlieker, *Possible Worlds*, exh. cat., ICA/Serpentine Gallery, London, 1990

3 Katharina Fritsch in conversation with Claudia Seelmann, 'King Kong and the Woman in White', *Damenwahl: Katharina Fritsch/Alexej Koschkarow*, exh. cat., Kunsthalle, Düsseldorf, 1999

4 Jane Tompkins, 'Language and Landscape: An Ontology for the Western', *Artforum*, New York, February 1990

5 Carolyn Christov-Bakargiev, 'Something Nowhere', *Flash Art*, Milan, May/June 1988

6 Katharina Fritsch in conversation with Matthias Winzen, *Katharina Fritsch*, exh. cat., San Francisco Museum of Modern Art and Museum für Gegenwartskunst, Basel, 1997

7 Christiane Hertel, 'Dis/Continuities in Dresden's Dances of Death', *Art Bulletin*, New York, March 2000, Vol. LXXXII, No 1

8 Caspar David Friedrich, *Monk by the Sea* (*Mönch am Meer*, 1808–10)

9 Werner Muensterberger, *Collecting: An Unruly Passion, Psychological Perspectives*, Princeton, 1994

10 Valeria Liebermann, 'Catalogue raisonné 1979–1996', *Katharina Fritsch*, op. cit.

11 Theodora Vischer, 'Des Pudels Kern – the Heart of the Matter', *Katharina Fritsch*, op. cit.

12 Katharina Fritsch in conversation with Matthias Winzen, *Katharina Fritsch*, op. cit.

The Same Hare

Edward Allington

Maybe it's the hum
of a calm refrigerator
cooling on a big night
maybe it's the hum
of our parents' voices
long ago in a soft light
mmmmmm[1]

I remember staying with Kasper König around 1990 when we were working on the Saarbrücken power station.[2] For this project I made a piece using a ship's searchlight called *Lichtempel* (*Light Temple*). Fischli/Weiss made an all-year-round snowman and Thomas Schütte modified the windows of the massive central tower so they looked like pictures of houses. All these works were parasites on the power station, as was Katharina Fritsch's *Mühle* (*Mill*, 1990), which sat like a giant toy, its wheel turning despite being on dry land. The television was on and Kasper and I were watching a political interview programme. I understood very little, but it was fascinating; the interviewer was being outrageously insistent and the level of his interrogation struck me as parallel to the act of making sculpture. To make sculpture is to be driven to the point where an image or an idea is not enough to answer the questions which motivate you as an artist; you simply have to make a complete three-dimensional object, and even that is not enough – you have to keep making more of them.

Fritsch made her first mill, *Graue Mühle* (*Grey Mill*), in 1979: it was only 8-centimetres (3-inches) long. A decade later she returned to the same image, but bigger, 7-metres (23-foot) high, sited in the landscape but retaining the same toy-like qualities as the first one and dependent upon a child-like act of the imagination to render it real. Why is it there? Like the interviewer in the television programme, we would like to ask a question and to have that question answered, but it is hard to know what to ask, for if we believe in the *Mühle* then the

Mühle (*Mill*), 1990
Concrete, wood, motor
Height 700 cm (275⁹⁄₁₆ in)

Parfüm im Hausflur (*Perfume in the Hallway*), 1984
Perfume, hallway

landscape is the wrong size and we cannot believe in either the landscape or in ourselves. If we choose to believe in the landscape, then the *Mühle* should not be there, but it is. It would be all right if this were just a photograph: photographs are like vitrines, and we all know that anything in a vitrine is mediated, and hence safe. But this is not a photograph, it is a very large and very real sculpture and, what is more, it is moving. We feel uncomfortable, we are in the realm the uncanny – the weird or unknown – and the unknown is a difficult place to be.

So let us start with something we all know, such as the noise of a refrigerator, the comfortable almost not-there sound of home. There is a work by Fritsch that has always fascinated me: I know it only through a catalogue photograph, the ultimate photographic vitrine at least two removes away from reality. It is called *Parfüm in Hausflur*. It is just a photograph of a staircase with a title, but when I look at it I imagine a familiar smell, I remember something, but I am not sure what it is. I know what my refrigerator sounds like, I know what my staircase smells like, but what did that particular staircase smell like? I am reminded of something personal and familiar by a work which is neither familiar or personal. How does this happen? I do not know. However, I do have a clue.

In 1502 Albrecht Dürer made a watercolour of a young hare. It is a popular and much reproduced image. It would seem that Fritsch and I have something else in common other than an interest in archetypes and formal issues relating to cultural memory, for I am told that a reproduction of this picture hung on a wall in her parental

home. One hung on the wall in my parents' house as well. Which is where my clue comes in. In this picture we see an incredibly detailed depiction of a young hare, a creature that in Western folklore is associated with good luck: it sits on a blank page, running from left to right, at almost 45 degrees, the angle of oblique projection; there is a shadow and, breaking the realism of the image, the date 1502 and Dürer's characteristic initials. I remember the picture of the hare, and I remember real hares, live and quick in the fields – and dead, skinned and dripping blood into buckets. Occasionally my father would shoot one. My mother hated the smell of their blood, but she would dutifully take them into the kitchen and cook them. She made pies of them. The drawing delivers a kind of poignancy: we are looking at a real animal which Dürer observed in minute detail 500 years ago, yet simultaneously this is a hare to

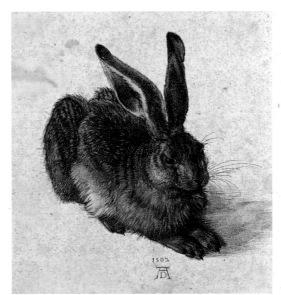

Albrecht Dürer
Young Hare, 1502

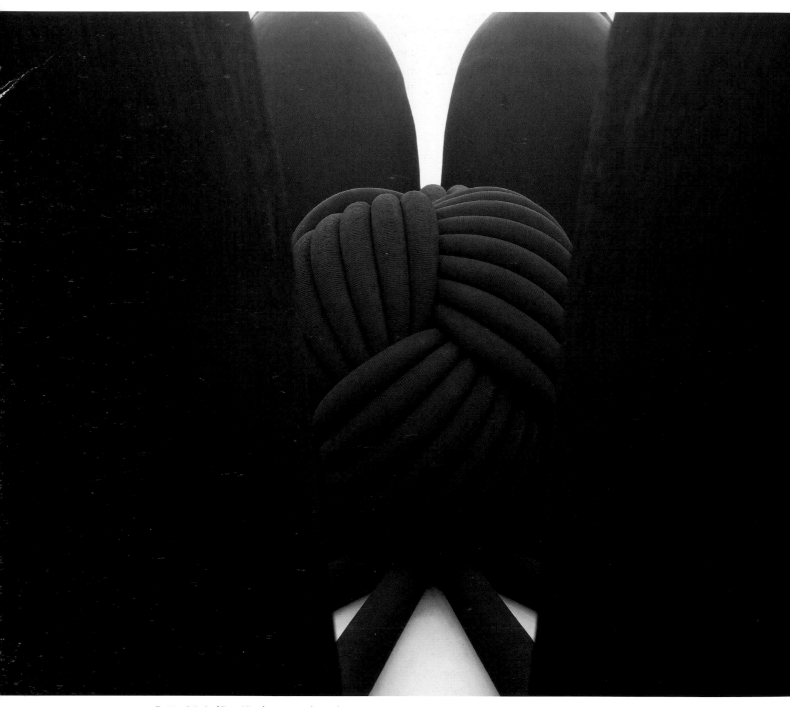

Rattenkönig (Rat-King), 1991–3 (detail)
Polyester, paint
Diameter 1300 cm, height 280 cm
(diameter 511¹³⁄₁₆ in, height 110½ in)

represent all hares. It was a period when, as art historian Erwin Panofsky describes it,

> 'while subjecting the visual experience of space to the rules of projective geometry, [Dürer] became all the more deeply engrossed in the minute details and individual differences of God's creation'.[3]

This is where the problem becomes metaphysical due to the dualism peculiar to Western Christianity: the division of human faculties into material and immaterial, the basis of this being the mind/body dualism that was essential to Plato's notion of the soul. Within Plato's philosophy it was essential that there was an eternal state of being, a constant and timeless sphere – separate from reality, the world of change – from which the soul had come and to which it sought to return. To achieve this he created a system of logic which argued the existence of a metaphysical realm. His arguments were later incorporated into the mysticism of Christian thought. This notion is exemplified by the famous image of the cave, where humanity is represented as being within a cave with its back to the sun, watching the shadows cast upon the wall of the cave and believing them to be real. In this image the light of the sun represents the separate world of perfect forms, archetypes and truth. Dürer's hare demonstrates this, for although a real hare is depicted in detail, it sits on an empty page with only a shadow, like the shadows in Plato's metaphor, the shadows of earthly existence. It is thus simultaneously a real and an ideal hare. The interesting aspect of this duality in relation to Fritsch's work is more than the use of clear space around her sculpture: her particularity in how they are exhibited ensures a very clear, formal figure-to-ground relationship situating them within the aesthetic concept of 'the beautiful'. Dürer's hare is beautiful in this way; it is clearly depicted on an almost empty page or ground, giving a psychological indication of strong self-identity, of continuity and changelessness. Many of Fritsch's sculptures work in precisely this way, the gallery space acting as the ground. Whereas with the sublime, the ground subsumes the figure. The aesthetic notion of the sublime is perhaps best exemplified by a painting such as Caspar David Friedrich's The 'Chasseur' in the Forest of 1813, where the small figure of a solitary hunter is overwhelmed by the forest he is about to enter. This painting, in common with most works of art using the aesthetic concept of the sublime, renders the human presence as insignificant before the ever-changing, incomprehensible phenomena of the natural world, evoking a sense of insignificance and disillusion of the self in the spectator; precisely that sensation of doubt that Mühle poses when seen in the flesh. It would seem that Fritsch's work operates or uses both of these aesthetic principles.

As Thomas McEvilley demonstrates in his brilliant and succinct essay: 'I Think Therefore I Art',[4] aesthetic formalism can be related to mind/body dualism, and Dürer's hare must be seen within this duality. But Fritsch's work is more complex, more subtly subversive, for she seems to play with these formal concepts of figure-to-ground through the use of scale, continuity and repetition. The work has the formal dualism of Dürer's hare, and thus is beautiful, yet when we confront it we experience

something more akin to the sublime. Why? As McEvilly states,

'In the aesthetics of thought the sublime is experienced, among other places, in the way the infinity concept interposes enormous abysses of non-identity into the world of other concepts.'[5]

If the dualism within Western thought is an attempt to construct continuity by the denial of change through the invention of a superior metaphysical world, then how does continuity manifest itself in the real world?

Back to my clue: just how many hare pies did my mother make? She made them and we ate them, and of course the hares kept reproducing – this being one of the reasons they are a lucky symbol, a symbol of fertility associated with spring, inverted in Christian symbolism to a white hare seated below the virgin as a symbol of chastity (and, in a curious image resembling Fritsch's knot of rat tails, a triangle of hares with conjoined tails representing the trinity). This is the continuity of hidden labour where the same things continue to appear because they are continually remade. Cooking is a good metaphor for this form of continuity. In the preparation of food, like sculpture, the real labour usually remains hidden. Let us take Fritsch's *Gehirn* (*Brain* 1987/9) as an example – not forgetting that the brain is not only the image of the mind, but, for cannibals at least (this being a human brain), it is also food. Historian and social analyst Margaret Visser, in her book *The Rituals of Dinner: The Origins, Evolution, Eccentricities and Meaning of Table Manners*, emphasises that the ethos of food is related to the fear of cannibalism, the violence of food production and of its consumption.[6] Eating is about the body: Christianity, through the Eucharist, is founded upon it. One variant of *Gehirn – Warengestell mit Gehirnen* (*Display Stand with Brains*, 1989) – presents multiple casts of this brain stacked like cakes on glass shelves, each circle of glass supported by the casts beneath it. First of all there is the model, in this case an anatomical cast of a human brain; from this model there will be a mould; plaster is mixed and poured into the mould. Not all the casts will be perfect, some will be rejected, and even the good casts will have to be fettled or cleaned. The same form is made and remade. We do not see this labour, it is hidden; and sculpture, because it has to be physically constructed in the flesh, has to be as real as the people looking at it, as real as a hare pie. Any flaw in its construction, and more importantly in the coherence of its construction, and it will fail. Unlike a photograph, there is no latitude for parts being out of focus. Fritsch makes sculpture that is absolutely coherent and that within its own terms is flawless.

But when I think of my clue, the picture, something else happens. I can remember my childhood home in detail: there is the hare, and below it the chest, or kist (for in the Westmoreland dialect a chest was a kist, just as it is in German; the county is now known as Cumbria and better-known still as the Lake District), and then there are the ornaments on the kist, the mirror and the small bookcase. The picture has functioned in the way Frances A. Yates describes in her book on the art of memory.[7] Before the invention of reproductive printing,

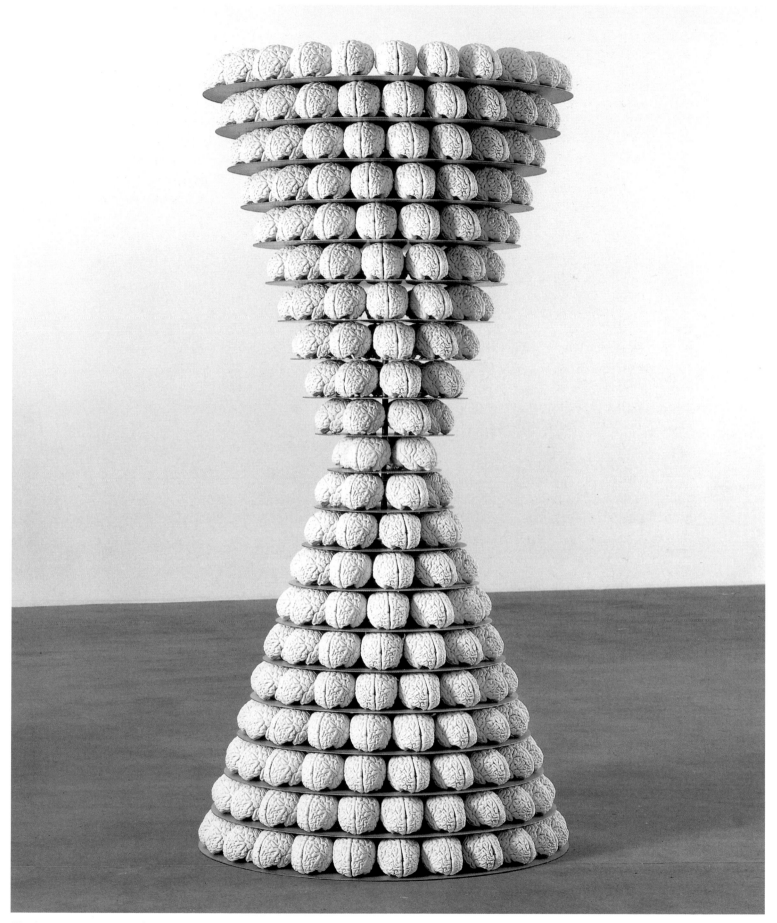

Warengestell mit Gehirnen (Display Stand with Brains), 1989
Plexiglas, plastic, paint
Diameter 120 cm, height 250 cm (diameter 47¼ in, height 78¾ in)

which rendered texts universally available, memory was one of the arts – it was essential. The acquisition of knowledge was useless without the ability to remember it. The invention of this art is attributed to the Greek poet Simonides of Ceos, who, after reciting a lyric poem in honour of his host, Scopas, was told that he would be paid only half the agreed fee as he had devoted half the poem to Castor and Pollux. He was then told that there were two young men waiting outside the house to meet him – the same twin gods to whom he had devoted half his panegyric. They drew him out of the house just before it collapsed, killing all who were in it. Simonides was thus paid in full for his work. He helped the relatives identify the dead by remembering where they sat. His mnemonic system

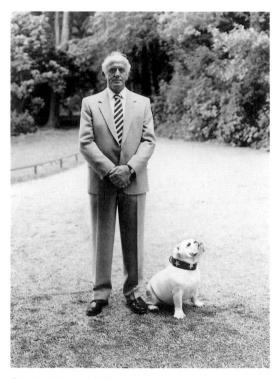

Spaziergänger mit Hund
(*Man Out for a Walk with Dog*), 1986
Mr. Reimers with English bulldog Rose, Arnheim

depended on the notion of remembering a place and then mentally locating information within the details of that place. I would like to suggest that Fritsch's work also functions in this way – we see it and we remember something, something personal and hence seemingly unrelated to the work, a sensation that contributes to the sense of unease that her work provokes.

Dürer's hare is very detailed, perhaps too detailed. In Fritsch's work we find something similar. There is for instance a man employed to walk a dog in a park, *Spaziergänger mit Hund*: he is neatly dressed – too neatly; his dog is an English bulldog wearing a most peculiar collar, bright red with stars on it. This was a brilliant piece of public art, for what do we expect to see in parks? Why, men walking dogs of course. Men presumably escaping the domestic realm, the feminine space of the home. The man becomes a representation of all men walking dogs in all parks. But he is just too neat, there is something wrong and alienating. The more we think about this work the more disturbing it becomes; we seem to be confronting the banality of everyday life with all the meaning stripped out even of that. It is not his dog, he is not escaping from domestic life, not asserting his independence and masculine difference from the feminine. There is no wife at home, no home to which he will happily return with his dog. In a cunning reversal he is a man employed by a woman to look as if he is doing these things. Normally the sight of a man walking a dog is a reassuring sight; normal life continues. But what if all the men walking all the dogs in all the parks in the world were in fact being employed by Fritsch? What would that mean? It would be

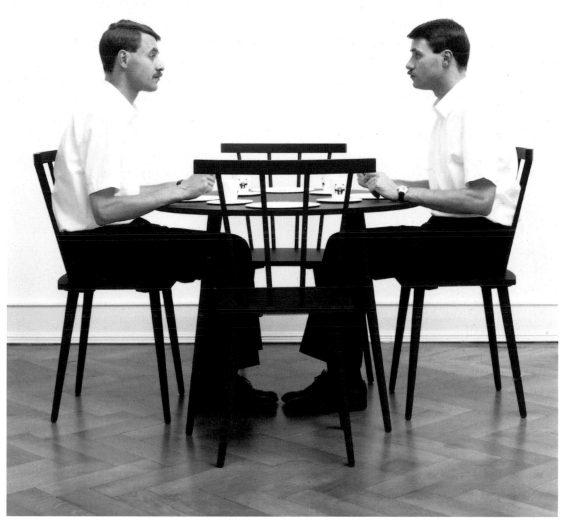

Schwarzer Tisch mit eineiigen Zwillingen
(*Black Table with Identical Twins*), 1985
Mr. Wiegmann and Mr. Wiegmann, wood, paint, plastic
Diameter 150 cm, height 150 cm (diameter 59 1/16 in,
height 59 1/16 in)

very funny, but would it be reassuring? We like to think of things having a place in the world. It is this notion that gives them the potential to hold meaning; it is a question of belonging. A man walking a dog in a park is not supposed to be a work of art by a female artist. If that place of belonging is destroyed then so is the potential to hold meaning. We seem to be faced with something familiar, but devoid of meaning and hence devoid of hope. Is this nihilism? No, I think not. The work does present a form of negation, but if, as I have suggested, Dürer's hare represents the dualism of Western Christian thought, of God's control over the form of the world and the imagined metaphysical world above, it also represents paternalism. This is the world that

Fritsch's work negates. Let us not forget that the German philosopher Friedrich Nietzsche declared the death of God in 1882, and hence marked the beginning of the modern secular era. However, his attempts to rationalise this loss of metaphysical hope ended with a further dualism: active or passive nihilism, the Apollonian or Dionysian, those that act despite there being no hope of salvation and those that surrender to that loss. In Fritsch's *Schwarzer Tisch mit eineiigen Zwillingen*, twins sporting less florid mustaches than Nietzsche face each other across a table as if they represent the continuing duality of Western thought while waiting for their dinner. One suspects they are not going to be fed. Fritsch's answer lies outside this

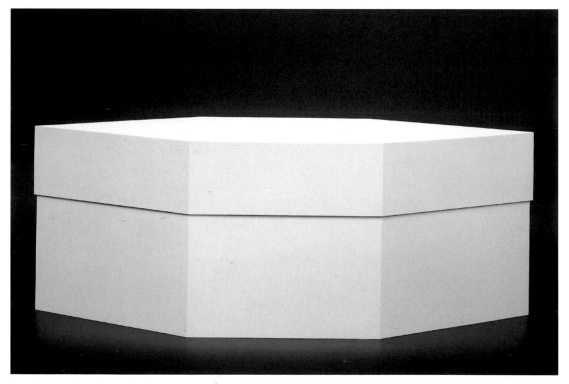

Pappkarton (Cardboard Box), 2000
Plastic, paint
110 × 40 × 40 cm (43½ × 16⅛ × 16⅛ in)

Bücherregal (Bookcase), 1986
Wood, paint, plastic, cardboard, paper
30 × 100 × 240 cm (11¹³⁄₁₆ × 39⅜ × 94½ in)

discourse. Cultural theorist Norman Bryson describes this position with great lucidity in the chapter 'Still Life and Feminine Space' in his book *Looking at the Overlooked*.[8] In this essay he not only clearly defines feminine space, but also clearly outlines the argument above in relation to still-life painting:

'the painting of what is "mundane" or "sordid" (*rhyparos*) is negative only from a certain viewpoint, in which the "lowness" of a supposedly low-plane reality poses a threat to another level of culture that regards itself as having access to superior or exalted modes of experience. And if that humble line is evaluated negatively, we need to inquire what kind of threat it could conceivably pose (if indeed it is so lowly), and for whom.'[9]

The threat is to paternalistic capitalist values, and Fritsch does this by working with something else Bryson refers to: the notion of 'prime objects', those objects that change but stay the same, tools and domestic objects such as plates and cups and vases.[10] These categories of objects are common in Fritsch's work. Consider *Pappkarton* (*Cardboard Box*, 2000), *Vase mit Schiff* (*Vase with Ship*, 1987/8) or *Bücherregal* (*Bookcase*, 1986). *Bücherregal* evokes the act of completion that all collectors desire: there are no titles, no contents; it too is a prime object. Not only does Fritsch assault these values symbolically, but she also assaults them through the Keynsian economics of her multiple production – the economics of mass production. The feminine when associated with economic exchange is, even now, more usually a form of social currency – as Margaret Visser writes, equating the female with food:

'Women have always been another symbol, used for the knitting together of families and tribes; they too are "given away" in marriage, shared, stolen, used to enhance status or abstained from.'[11]

Take Fritsch's 1988 work *Geldkisten* (*Money Chests*). Four boxes are filled with coins, but Fritsch made these coins, they are blank, she sells them; coins are also prime objects. In a reversal of Visser's dictum, Fritsch is controlling the system of exchange, she is not subject to it. The result is weird – a word derived from the Anglo Saxon 'wyrd', meaning 'tied to fate and destiny' and sometimes used in medieval English poetry to denote something caught in time's grip: one of its synonyms is 'uncanny'. To unravel this word, which is commonly used to describe Fritsch's work, let us return to Bryson, who relates how for Freud the uncanny is always the product of the re-emergence of earlier memories – memories of infancy. He quotes Freud:

'It often happens that neurotic men declare they feel there is something uncanny about the female genital organs. This *unheimlich* place, however, is the entrance to the former *heim* (home) of all human beings, the place where each of us once lived once upon a time and in the beginning. There is a joke saying that "love is home-sickness": and whenever a man dreams of a place or country and says to himself, while he is dreaming: "this place is familiar to me, I've been there before", we may interpret the place as being his mother's genitals or body. In this case … the *unheimlich* is what was once *heimisch*, familiar; the prefix "un-" is the token of repression.'[12]

The feeling he describes as 'this *unheimlich* place' is, I think, the one we feel before Fritsch's work, a feeling which is also tinged with a wry humour. The shift in scale and the almost fairy-tale insistence of her images takes us close to memories we know but cannot actually remember. As 'Alain', the philosopher Emile-Auguste Chartier, known to his more famous pupils such as Simone Weil and Jean-Paul Sartre as simply 'l'homme', states in his book *The Gods*, 'the state of childhood … is doubtless only the yesterday of all our thoughts … forgetfulness is the law of childhood; I mean that in childhood there is no remembrance, though memory is faithful and faultless. We push our childhood before us, and that is our real future.'[13]

Using this idea of forgetting, of pushing our childhood before us, Alain proposes a dialectic of childhood. The fairy-tale script of our infancy as recounted to us by our parents is in continual conflict with the suppressed subconscious effects of our infancy (which I take to mean that which we remember as opposed to that which we have all forgotten, which is as Alain describes it, 'the substance of dreams'[14]), a realm we now confront through psychoanalysis. This is where Fritsch's work takes us to the uncanny world of childhood, and she does this with things, with sculpture.

That in the end is where Dürer's hare, my clue, the key to my question, has led me. We cannot know what actual effect that same hare had on her work or on mine, but it leaves me with the conclusion that Katharina Fritsch has attacked – and I think attacked is the right word – these issues from a profoundly feminist position. She has attacked the notion of the sexuality of space, of stereotypes of feminine economic exchange, with a methodology of object-making, reproduction and representation that leaves us speechless. She gives us a world where continuity is represented in a different way. The memories the work evokes belong to a childhood world where remembrance does not truly belong: that is where the power of her work lies; its familiarity is less the sound of a refrigerator on a big night, more the hum of our parents' voices long ago in a soft light … mmmmmm.

1 'Changing Opinion', Philip Glass/ Paul Simon; Bernard Fowler, Vocals; Michael Riesman, Piano; Paul Dunkel, Flute. Philip Glass: *Liquid Days*, CBS, 1986
2 *Das Kunstprojeckt Heizkraftwerk*, exh. cat., Römerbrücke, Saarbrücken. Curated by Kasper König, architects Jourdan and Muller P.A.S., Frankfurt
3 Erwin Panofsky, *The Life and Art of Albrecht Dürer*, Princeton, 4th edition, 1995, p.80
4 Thomas McEvilley, 'I Think Therefore I Art', *Artforum*, New York, Summer 1985, pp.74–84
5 Ibid., p.76
6 Margaret Visser, *The Rituals of Dinner: The Origins, Evolution, Eccentricities and Meaning of Table Manners*, London, 1992
7 Frances A. Yates, *The Art of Memory*, London, 1966
8 Norman Bryson, *Looking at the Overlooked: Four Essays on Still Life*, London, 1990
9 Ibid., p.137
10 Ibid., p.138
11 Visser, op. cit., p.3
12 Freud quoted in Bryson, op. cit., p.171
13 Emile-Auguste Chartier Alain (1868–1951), *The Gods*, trans. Richard Pervear, London, 1975, p.26
14 Ibid., p.27

Multiples

Iwona Blazwick

Modern and contemporary artists have co-opted the technologies of industrial mass production to create and distribute works of art variously termed multiples, editions, printed matter or mail art. This strategy was pre-eminent in the 1960s and early 1970s when there was a widespread interest among artists in creating prints and books as works of art, most famously as part of the Fluxus, Conceptual and mail art movements. The multiple has re-emerged in recent contemporary art and is an important strand in the work of Katharina Fritsch.

The multiple offers the artist many possibilities. Standardised in production, it can be made more cheaply and sold at a lower price than a unique work – the multiple offers the struggling artist a way of surviving economically while giving ordinary people the opportunity to own a work of art. Usually modest in scale, the multiple can enter the domestic realm, taking its place among personal possessions. Through juxtaposition with the quotidian objects of daily life, works such as Fritsch's *Madonnenfigur* reinvests a typical figurine, made kitsch by mass production, with a new aura. The issue of distribution is central to the significance of multiples as art forms; they carry the artist's vision to a wide audience, resonating within the lived experience of their owners. In this democratisation of art and its communicative possibilities, the multiple can be understood as a form that is both poetic and political.

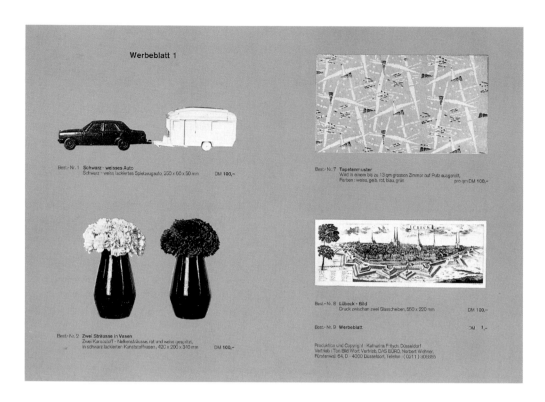

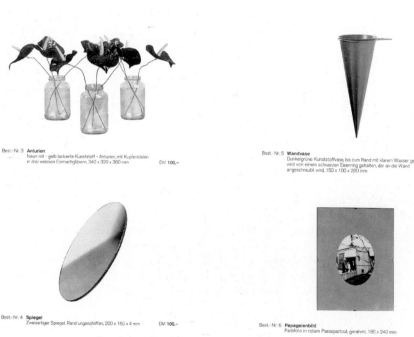

Werbeblatt I (***Advertising Leaflet I***), 1981
Paper, offset printing
29.7 × 21.1 cm each page (11^{11}/$_{16}$ × 8^{1}/$_{2}$ in each page)

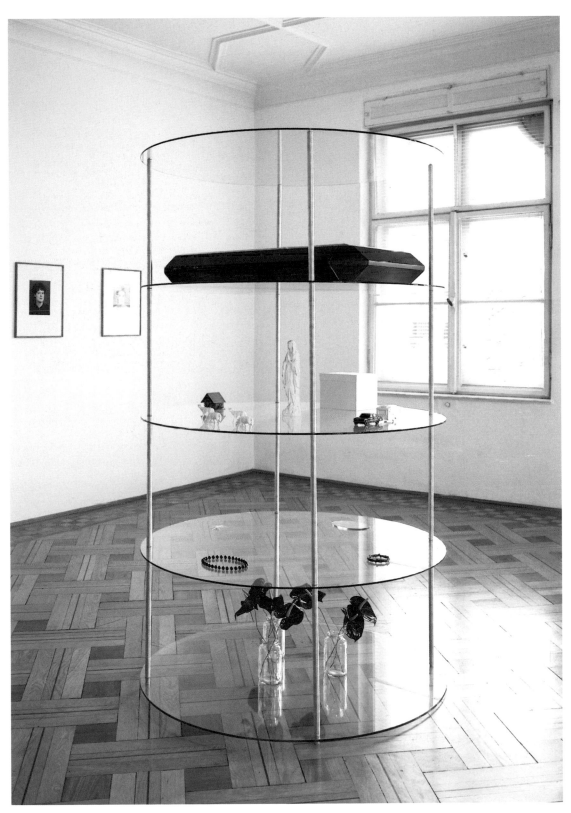

*Warengestell (**Display Stand**)*, 1979–84
Glass, aluminium, objects dating from 1979–84
Diameter 120 cm, height 203 cm (diameter 47¼ in,
height 79¹⁵/₁₆ in)

Katze (Cat), 1981/9
Synthetic material
6 × 17 × 17 cm (2⅜ × 6¹¹⁄₁₆ × 6¹¹⁄₁₆ in)

60 *Madonnenfigur (Madonna Figure)*, 1982
Plaster of Paris, paint
6 × 8 × 30 cm (2⅜ × 3⅛ × 11¹³⁄₁₆ in)

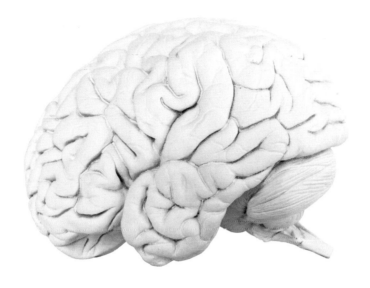

*Gehirn (**Brain**)*, 1987/9
Plaster of Paris, paint
15 × 13 × 11.5 cm (5⅞ × 5⅛ × 4½ in)

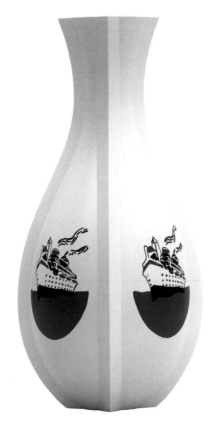

*Vase mit Schiff (**Vase with Ship**)*, 1987–8
Plastic, silkscreen print
Diameter 12.5 cm, height 30 cm
(diameter 4¹⁵⁄₁₆ in, height 11¹³⁄₁₆ in)

62 *Beistelltisch mit Engel und Flasche*
 (*Side Table with Angel and Bottle*), 1985
 Wood, paint, Plexiglas, sheet tin
 80 × 40 × 50 cm (31½ × 15¾ × 19¹¹⁄₁₆ in)

Unken (*Toads*), 1982/8/90
Krankenwagen (*Ambulance*), 1990
Mühle (*Mill*), 1990
7-in, 45rpm vinyl records

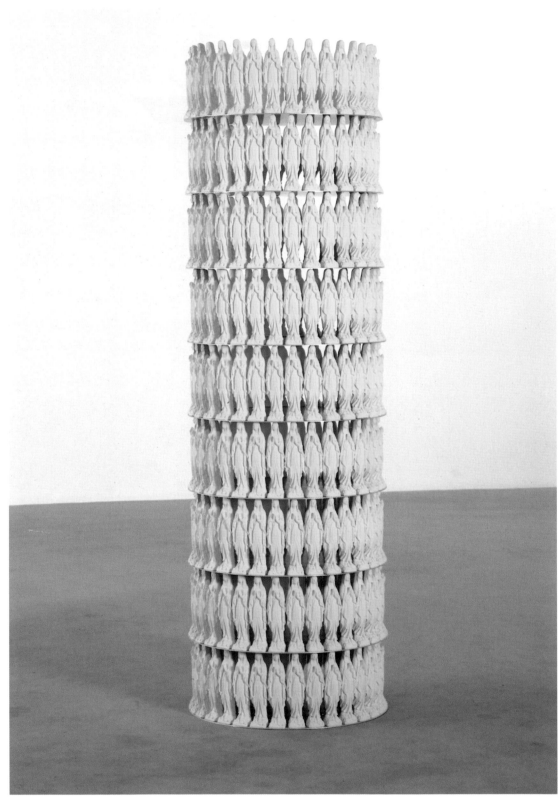

64 *Warengestell mit Madonnen*
(*Display Stand with Madonnas*), 1987/9
Aluminium, plaster of Paris, paint
Diameter 82 cm, height 270 cm (diameter 32 ⁵⁄₁₆ in,
height 106 ⁵⁄₁₆ in)

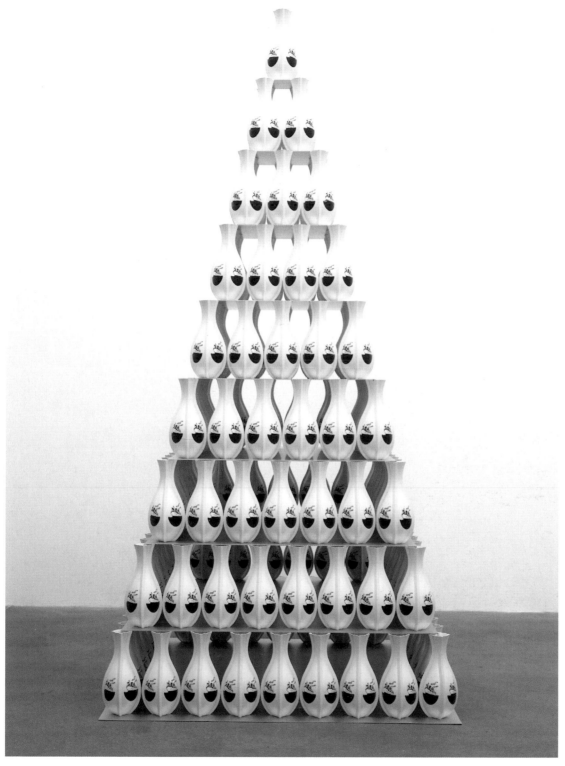

Warengestell mit Vasen
(*Display Stand with Vases*), 1987/2001
Plastic, silkscreen print, aluminium
127 × 127 × 270 cm (50 × 50 × 160 in)

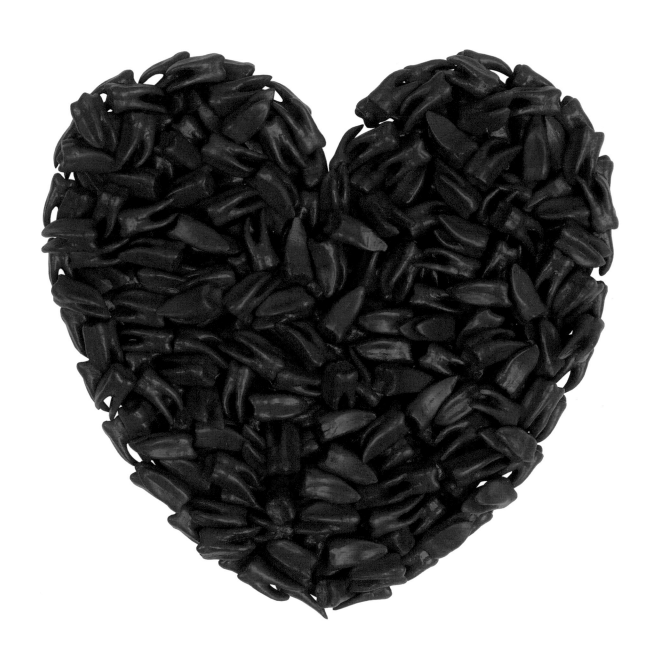

66 *Herz mit Zähnen (Heart with Teeth)*, 1998
Resin, paint
20 × 20 × 0.8 cm (9⅞ × 9⅞ × 3⅛ in)

Kreuz (Cross), 2001
Plexiglas, paint
20 × 20 × 2 cm (7⅞ × 7⅞ × 1 in)

68 *Totenkopf* (*Skull*), 1997/8
Zellan, paint
25 × 16 × 20 cm (9⅞ × 5¾ × 7⅞ in)

Giftflasche (*Poison Bottle*), 2001
Plastic, paint
10 × 10 × 25 cm (4 × 4 × 9⅞ in)

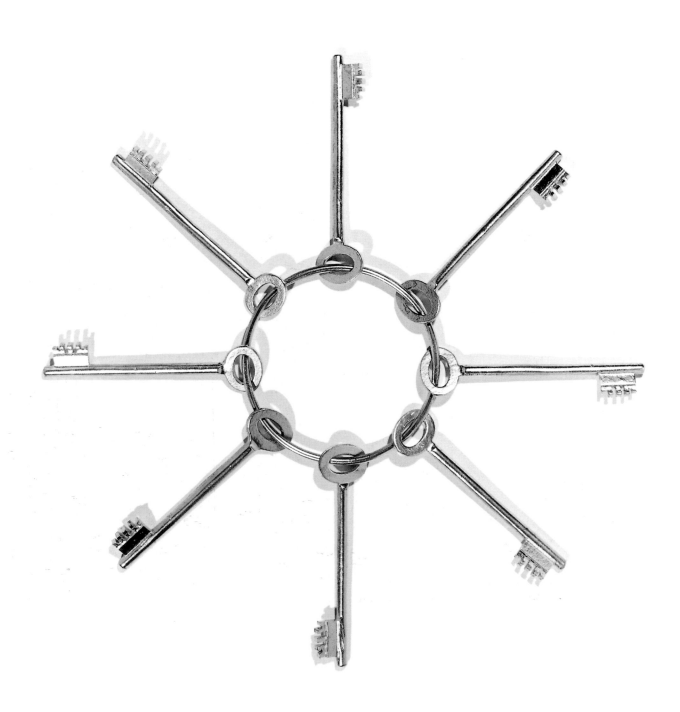

70 *Schlüsselring* (*Key Ring*), 1984
Metal, paint
Diameter 30 cm (diameter 11¹³⁄₁₆ in)

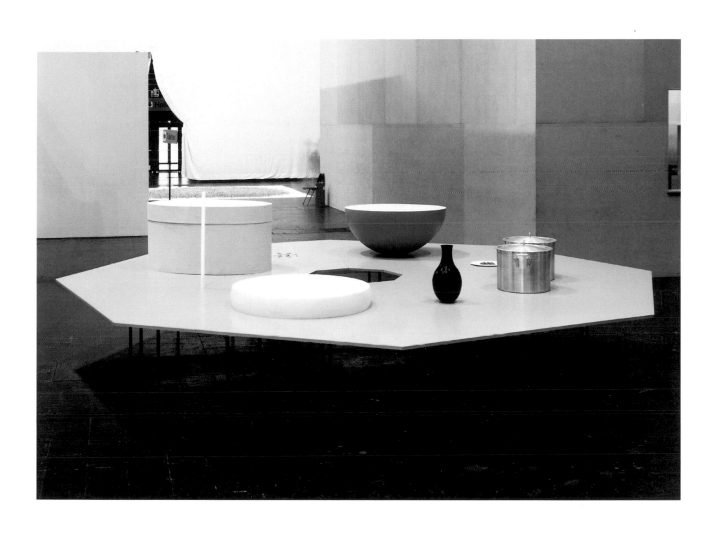

Acht Tische mit acht Gegenständen
(*Eight Tables with Eight Objects*), 1984 (detail)
MDF board, steel, objects dating from 1981–4
8 assembled tables, diameter 480 cm, height 155 cm
(diameter 189 in, height 61 in)

Irreconcilable in Space
How Some of Katharina Fritsch's Work Gets Under Your Skin

Bice Curiger

Where does this special tone, the currency of Katharina Fritsch's works, their presence geared entirely towards the here-and-now, come from? Their mixture of sculptural gravitas and flashes of wit? The artist positions her images with subtle precision. Compelling statements in themselves, her works reach into social, temporal and mental spaces, posited in the space of art or on the street, in buildings or outdoors. The Christian connotations of the new-born infant in *Kind mit Pudeln* (*Child with Poodles*, 1995–6) may unexpectedly conjure the secular resemblance between museum and church, while, conversely, the friction of placing the *Madonnenfigur* in a pedestrian zone in Münster makes an even more pointed reference to the essence of devotion as contemplation and commitment – detached from the customary religious context. Both art and life, in Fritsch's work, acquire a laboratory function where they ceaselessly feed into her investigations of a world thoroughly intertwined with weightless images.

In the art of the last century, the act of seeing was a frequent subject of critical analysis. With the emergence of abstract art, 'seeing as recognition' was clearly devalued in favour of a seeing which was the act of seeing autonmous pictorial means. Fritsch's exploratory journey leads us into a terrain where the two kinds of seeing have made a pact, showing how explosive their cross-pollination may be.

Fritsch bares images. She extracts them from the depths of daily use, from

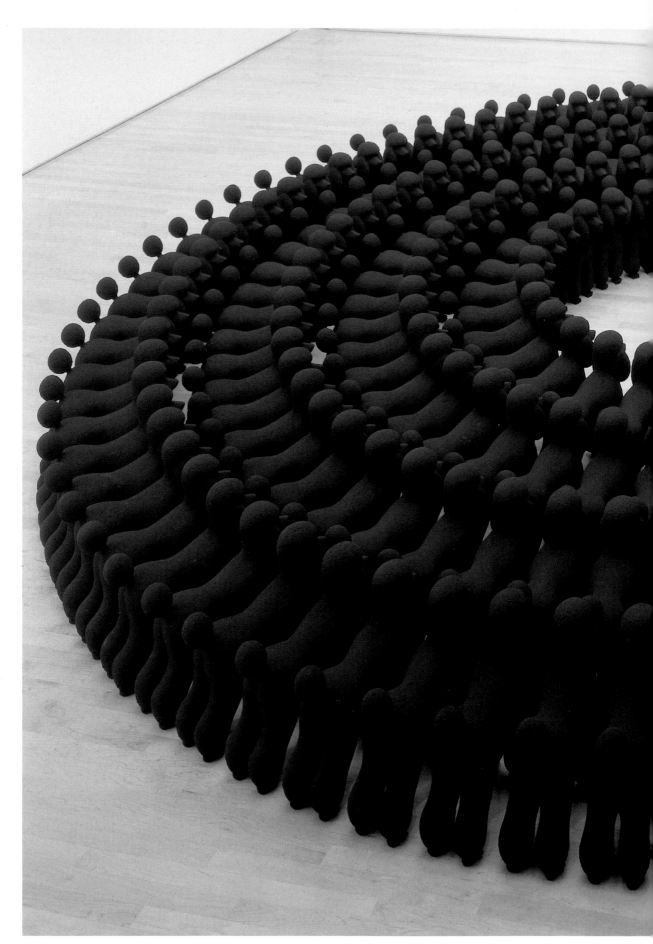

Kind mit Pudeln (Child with Poodles), 1995–6
Plaster of Paris, foil, polyurethane, paint
Diameter 512 cm, height 40 cm (diameter 201 9/16 in, height 15 1/2 in)

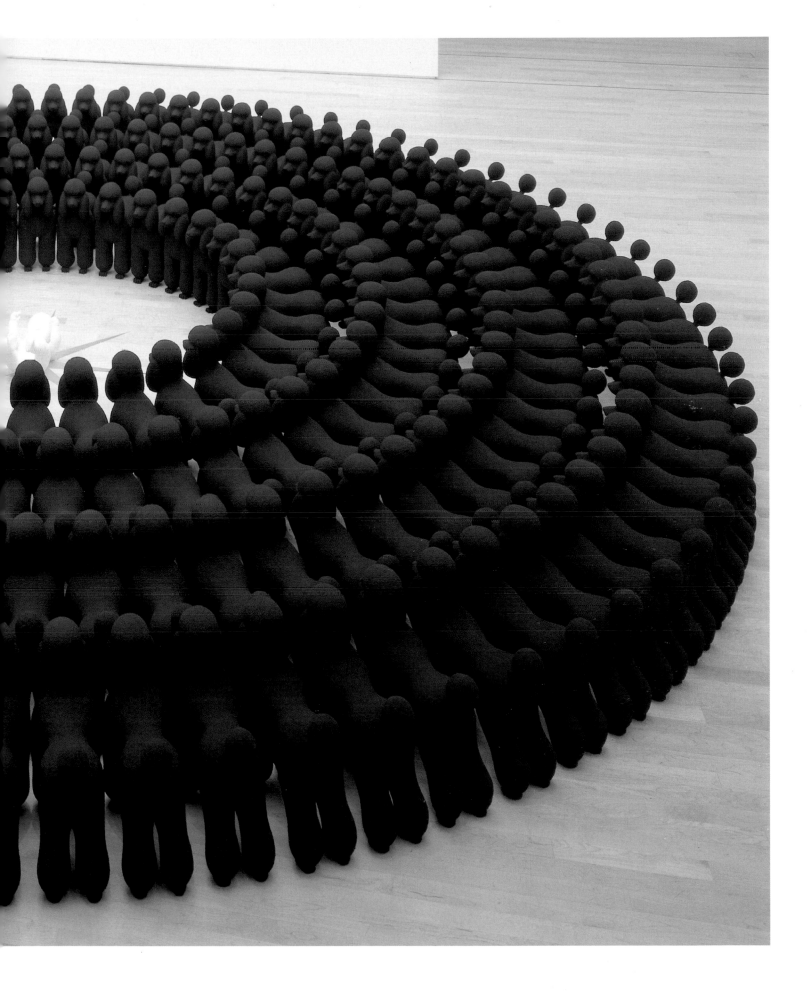

the wear and tear of contextual dependence, and invests them with startling freshness and vitality. Popular, accessible, age-old images such as a mushroom or Our Lady of Lourdes appear with such conceptual clarity in the works of this artist that they would seem to be elementary particles which eschew any temporary chemical combinations. Yet the primal urgency, the essential to which Fritsch aspires, is not achieved through the philological pursuit of, say, the original legend of a statue of the Madonna or its journey through time and the media enlisted in its representation – with all the rhizomatic deviations, shifts in emphasis, attempts at revitalisation, forms of ritualisation and individual appropriations attendant upon this history. Fritsch moves in the opposite direction. She ignores the larger semantic context of 'religious object', 'decoration', 'product of nature' or 'medical model', choosing instead to remain strictly within the image, digging into it and finding its innermost pulsating core, which is at once identical with what might be called the largest common denominator of experience.

Although Fritsch's investigations address popular culture, her works can hardly be characterised as Pop. They move farther afield, probing the past that lies behind the appearances of modern mass culture. And still they seem to embody the present, the entire potential of current experiences and ideas. Fundamentals like money and the display of merchandise crop up in her work, clearly demonstrating that they are as much subtly rooted in remote biblical antiquity and the fairy-tale worlds of thalers and ducats as they are attuned to the cellular conditioning of late-capitalist humanity.

The accessible, cheerfully chummy, exaggerated contours of Pop pictures, with their guaranteed 'high ratings' are entirely different from the

nature of the visual impact made by Fritsch's works. The latter are wild, brittle, reduced. They show a stringency, an irrefutable urgency achieved not through cultural probing alone, but also through a cogent formal structure. Bound into an ordering geometry of meticulously calculated proportions and symmetries, even the surfaces of these picture-objects convey the idea of a radiant new amalgam, yielding essences that transcend both time and system.

The immobility always brought into play in these objects tempts us to assume that they postulate static timelessness, rest or anaesthetising classicism: the opposite is true. Fritsch's works are imbued with a subtle and all-pervasive dynamic that cannot be ignored.

It happens in the act of viewing. What has been stored in a matter of seconds, as if burned onto the retina, is worlds removed from being comprehended with similar speed. Although everything seems buoyed by the inner motifs of understanding and recognition, the works offer no speedy and most certainly no conclusive resolution, despite their inescapably obvious articulation of subject matter. Fritsch confronts us with what Georges Didi-Huberman describes as the difference between the visible and the 'lisible' or legible.[1]

To illustrate, let us take a look at *Kind mit Pudeln*. We are immediately struck by the perfectly clear configuration of circle and centre in simple black and white. The broad margins are formed by a pitch-black ring that proves to be an extremely disciplined pack of seemingly countless poodles,[2] while in the centre a new-born infant lies radiant on a golden star, like part of an oversized crèche. The clarity of the piece is disconcerting.

Both the poodles and the infant are signs heavily charged with meaning which have travelled a long way – and for compelling reasons – before coming to a halt in the context of contemporary art. The perfectly-clipped poodle is the quintessential *petit bourgeois* pet, symbol of the emotional and aesthetic anti-avant-garde: the more it fades from today's city streets, the more intensely cloying does its image become as the embodiment of a post-war spirit. The symbolic connotations of the new-born infant could hardly be more diametrically opposed, as if to conjure that magical moment just before the jaws of civilisation snap shut. Or is this unsuspecting suckling already infected by the inescapable microbes of Christianity? Are the poodles protecting or threatening the infant? Despite a brief flash of comic insight into an elementary social situation, we sense the unease that is at once the starting point and the goal of Fritsch's oeuvre. This unsettling effect leads to a path of visual recognition and the deceptive certainties spawned by it. The recognition of (primal) images or modern 'pathos formulas' is interlaced, as we have seen, with dynamic resistance. And humour.

In *Tischgesellschaft* a young man is sitting at a table, motionless in the pensive attitude of one distracted. The extreme multiplication of the figure (thirty-two life-size repetitions) invests the sculpture with a sense of infinite movement. All-encompassing, it instantly pulls viewers into its irresistible maelstrom. Looking at this work means allowing oneself to drift and observe the too-solid earth giving way underfoot. But what do we actually see? A man, a table – the most rudimentary secular entity! Everything seems to fall into place in the geometrical pattern of the red and white tablecloth that evokes the days of early punch-card weaving techniques – all the details of

the figure's shape, the hands, the hairline, the profile of the face, the shape of the back – so that, on walking around the sculpture, one is assaulted with a dizzyingly psychedelic, three-dimensional array of constantly changing and re-forming ornamental patterns. As if it had been requisitioned by an utterly relentless, standardised reality, as the 'mass ornament' incarnate, to borrow the title of Siegfried Kracauer's famous essay of 1927.[3]

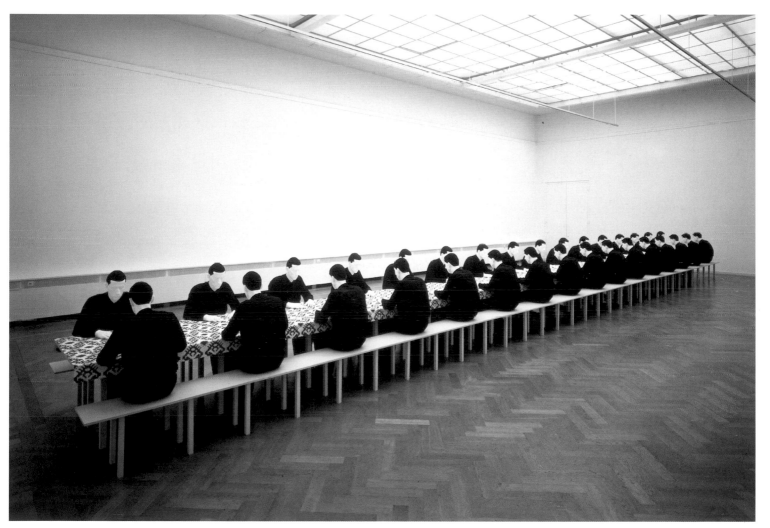

Tischgesellschaft (Company at Table), 1988
Polyester, wood, cotton, paint
1600 × 175 × 150 cm (629 ¹⁵⁄₁₆ × 68 ⁷⁄₈ × 59 in)

overleaf: *Gespenst und Blutlache*
(*Ghost and Pool of Blood*), 1988
Polyester, paint, Plexiglas, lacquer
Ghost, 60 × 60 × 200 cm (23 ⅝ × 23 ⅝ × 78 ¾ in)
Pool of blood, 53.2 × 209.4 cm (20 ¹⁵⁄₁₆ × 82 ⁷⁄₁₆ in)

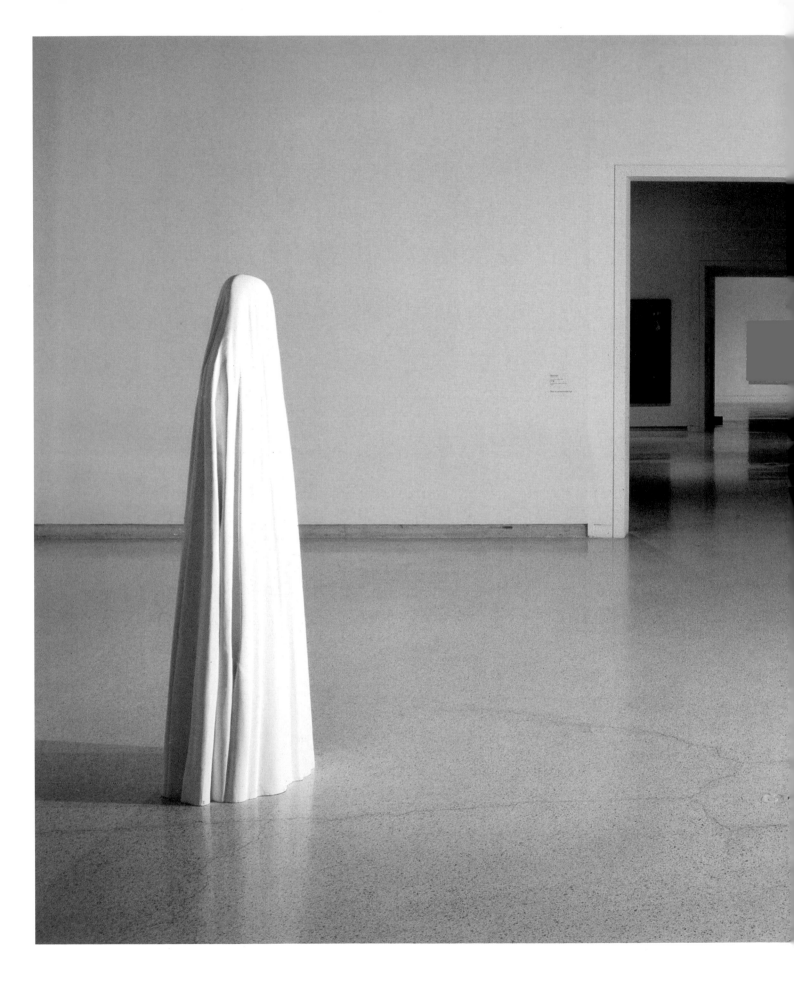

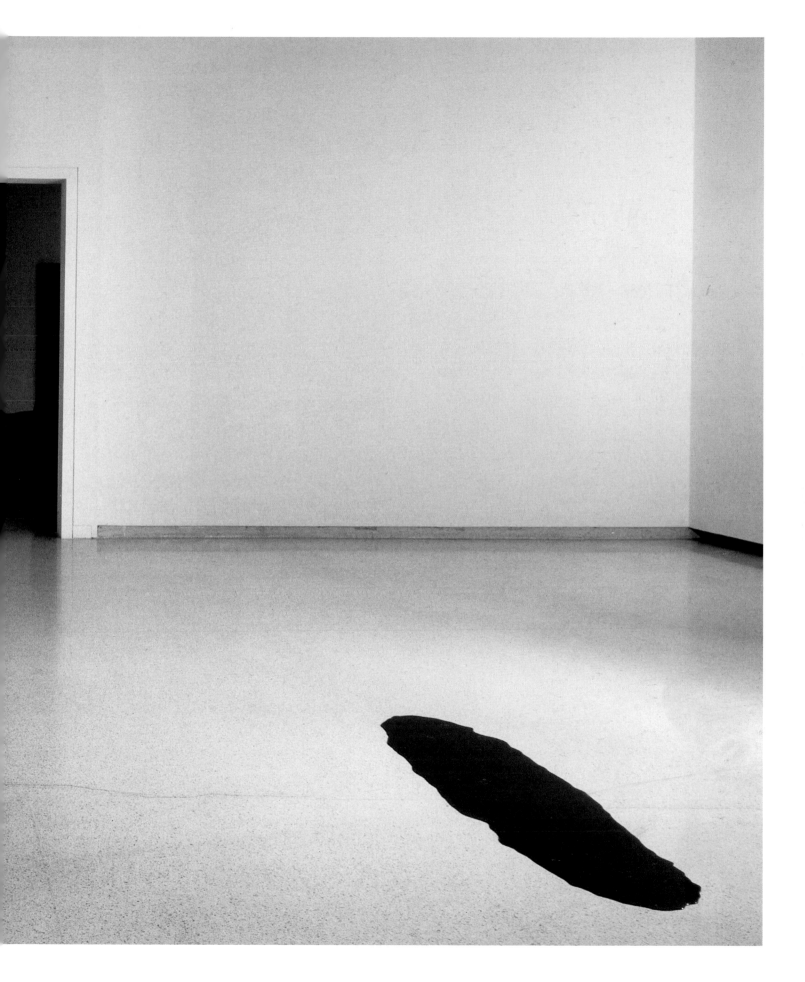

The visual recognition inherent in many of Fritsch's works recalls Freud's description of the uncanny and the recurrence of repressed thoughts. We know from Faust that the poodle is the devil incarnate and that Goethe himself was scared to death of dogs, especially poodles. He found them uncanny in the extreme, baneful harbingers of catastrophe. Fritsch has Mephistopheles come dancing out of the burst body of the poodle. On studying her sculptures, one finds that reference to the body acquires an impact precisely because it is fanned by the flame of psycho-physical mechanisms. The constitutive parameters of the picture begin to surface, reflecting the anthropological facts of humour and anxiety as pleasure – in a kind of pictorial metalinguistics.

Gespenst und Blutlache (*Ghost and Pool of Blood,* 1988) is a sculpture that embodies both a statue and a ghost – one might even say that the one simultaneously represents the other. Gazing upon the conflation of representation and represented soon discloses the (fake) blood forming an imposing pool in front of the statue. Almost like blood spilling in a cartoon, it is seen separated from the figure, this eyeless arrangement of folds with no body contours.[4] The sinister, rapacious blot on the floor flagrantly challenges the introspective, erratic and anaemic appearance of the cool, disembodied vertical monument. Yet the blood indisputably testifies to a causal entanglement and the untold potential horrors of erupted passion.

When *Rattenkönig* (*Rat-King*, 1991–3), was first put on display, it took such possession of the large ground-floor space at the Dia Center for the Arts in New York that visitors entering the room were caught completely off guard. The rigorously symmetrical ring of pitch-black rodents, sitting up on

their haunches and so oversized that they almost touched the ceiling, instantly bombarded viewers with a host of contradictions. This extraordinarily dominant, gigantic thing, miraculously arranged, joined and delicately produced, speaks with paradoxical menace of the hidden, suppressed aspects of our lives: of smut, of things repulsive, of things spreading uncontrollably, of putrefaction and decay – a mighty and 'artistic' spectacle for the art-loving public. But the fancifully eerie, fairy-tale cuteness does not rule out the fact that a gene-manipulated monster is lurking beneath the disguise. The neatly knotted cluster of tails, half hidden in the centre of the sculpture, ultimately acts as a focal point and symbol of the unacknowledged and inextricable entanglement of the irrational and the rational in our contemporary lives. It also symbolises a concentrated collective anxiety, still kept in check by ancient, arcane rites (the order! the knots!).

Fritsch's art is certainly not expressive; rather it is existential, lucid, even life-affirming and non-elitist. In *Doktor*, a humorous, light-heartedly laconic work of 1999, so-called 'higher logic' irrefutably demonstrates the fact of our lifelong dependency in the dual image of 'nurse/death'. The life-size figure in a white coat pointedly engages the interplay of reason, fear and forward-looking imagination. Recalling the poet August von Platen's famous lines, 'Whose eyes have gazed upon beauty / Is already given over to death',[5] one might say that Fritsch has created a new version of the old double image, but hers shows a complete lack of romanticism eminently suited to our pragmatic, health-obsessed age.

Hexenhaus und Pilz (*Witch's House and Mushroom*, 1999) is directed toward a collective fantasy world, found projected into the deep time-space

overleaf: *Rattenkönig* (*Rat-King*), 1991–3
Polyester, paint
Diameter 1300 cm, height 280 cm
(diameter 511¹³⁄₁₆ in, height 110½ in)

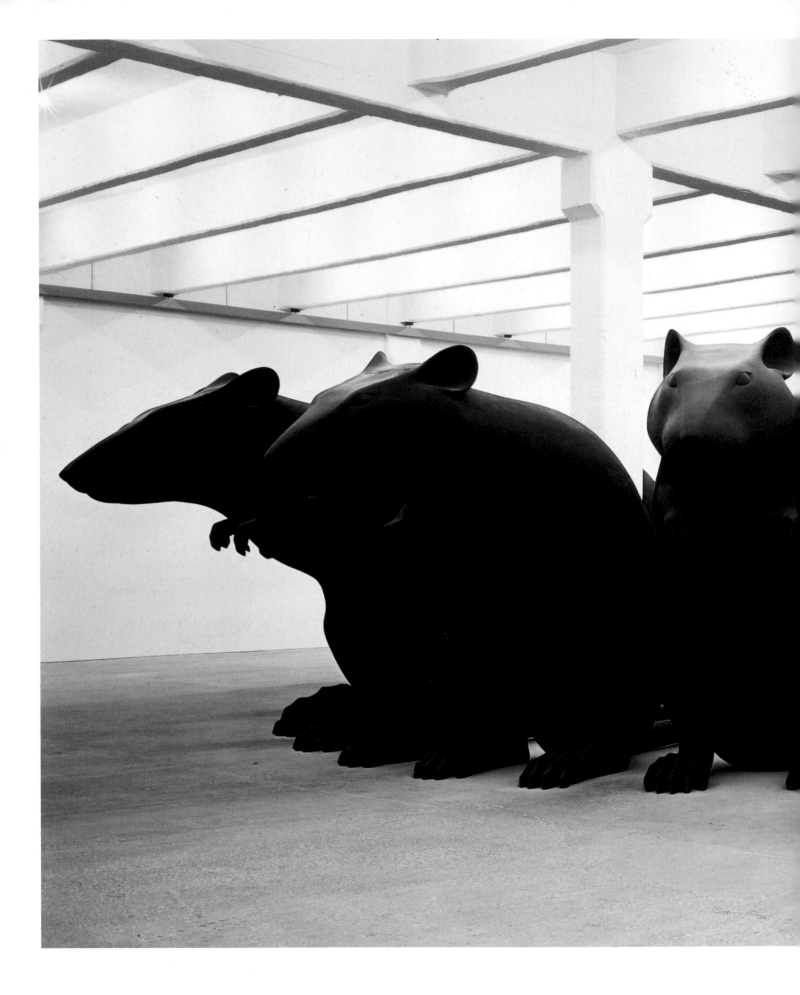

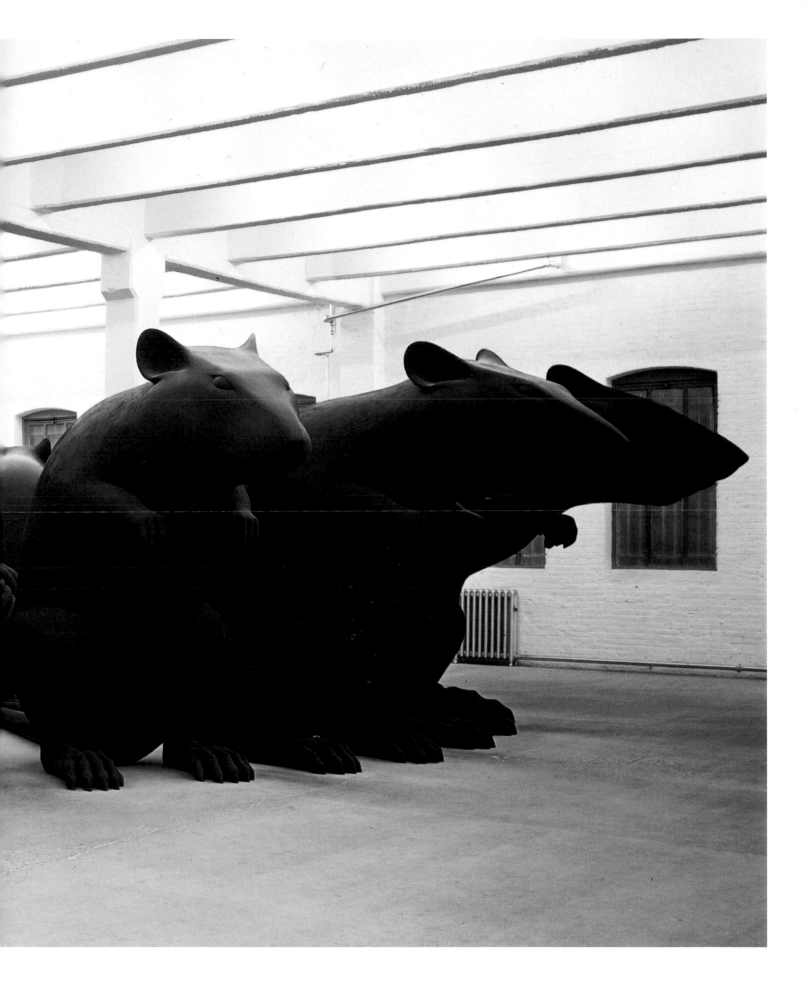

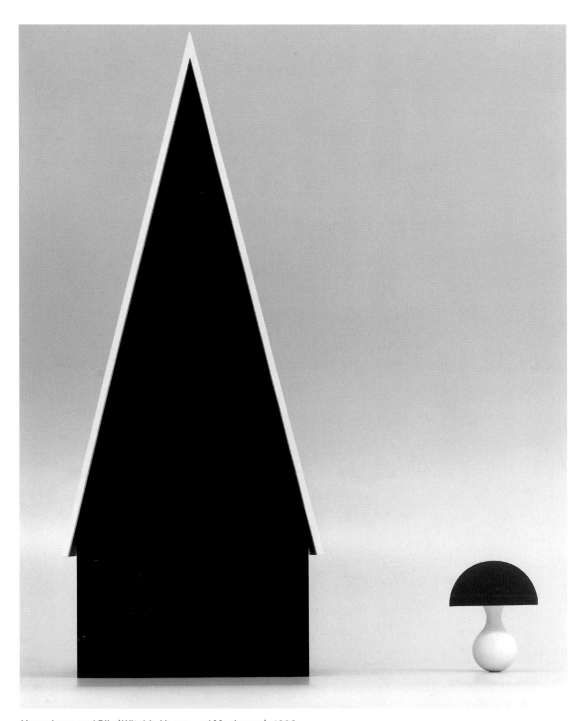

*Hexenhaus und Pilz (**Witch's House and Mushroom**)*, 1999
Wood, paint, plastic
Witch's house, 40 × 35 × 80 cm (15¾ × 13⅞ × 31½ in)
Mushroom, height 15 cm, diameter 12 cm (height 5⅞ in, diameter 4¾ in)

of fairy tales. The artist pares down the crisp little cottage, does away with its usual narrative ornamentation and offers an image infused with visual rationalism: mushroom, cottage – as if they had been transformed into radiantly meaningful signs according to the enlightened rules of French Revolutionary architecture. Cool, wry, floating objects, they conjure the power of myths and legend-based verities.

In *Lexikonzeichnungen* (*Fairy Stories*, 1996) Fritsch already dealt in lexical representations and formally transformed them into meta-signs. These images now carve an anthropological trail through the child's world of learning and exercises in cultural assimilation.

Fritsch's work ventures into territory where language and experience are explored, where the personal and the suprapersonal meet and merge. Her work takes the shape of radical gestures in the white cube, such as *Roter Raum mit Kamingeräusch* (*Red Room with Chimney Noise*), installed in

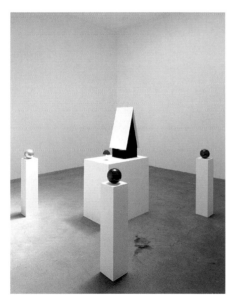 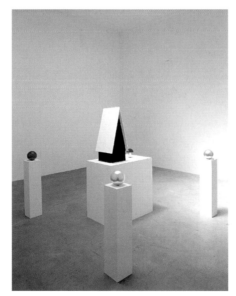 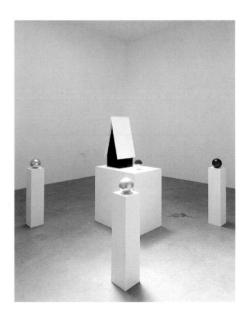

Hexenhaus und Pilz mit vier Kugeln (*Witch's House and Mushroom with Four Balls*), 1999
Wood, paint, plastic, aluminium
Witch's house, 40 × 35 × 80 cm (15 ½ × 13 ⅞ × 31 ½ in)
Mushroom, diameter 12 cm, height 15 cm (diameter 4 ¾ in, height 5 ⅞ in)
Balls, diameter 15 cm (diameter 5 ⅞ in)

88 *Silberne Kugel* (*Silver Ball*), 1999
Paint, plastic, aluminium
Diameter 15 cm (diameter 5⅞ in)

Goldene Kugel (***Golden Ball***), 1999
Paint, plastic, aluminium
Diameter 15 cm (diameter 5⁷⁄₈ in)

Roter Raum mit Kamingeräusch (Red Room with Chimney Noise), 1991
Paint, tape recorder
Martin Gropius Bau, Berlin

1991 in the Martin Gropius building as part of the 'Metropolis' exhibition in Berlin. The room was left empty; its walls were coated with a mixture of cadmium red in a complicated process, yielding an extremely vulnerable surface reminiscent of Yves Klein's paintings. The sound of wind howling through an absent chimney filled the room. It was soon evident that the windows were part of the piece. They looked out on a rubble heap in Berlin, now known as the 'topography of horror': the foundations of a former Gestapo building which once also housed a Nazi jail and a torture chamber. To the left one saw the wall, which had just collapsed, as well as the head-quarters of the Springer press empire, the centre of ideological influence in post-war Germany and the Cold War era.

Roter Raum made viewers feel trapped. The warm, velvety-red atmosphere seemed to appeal to a personal, associative field of memories, upon which was superimposed another, so to speak blazing red idea, just prevented from getting under one's skin on entering a contemporary art exhibition. It is a plot with no resolution, in which one has unwittingly become entangled – as so often in Katharina Fritsch's works.

1 The 'visible' and the '*lisible*' or 'legible', in Georges Didi-Huberman, *Devant l'image*, Paris, 1990, p.11; the author discusses art history and the consequences of promising to guarantee the explicability of all pictures.
2 224 to be exact
3 Siegfried Kracauer, *The Mass Ornament: Weimar Essays*, trans., ed. and intro. Thomas Y. Levin, Cambridge, Massachusetts, 1995

4 Isn't she reminiscent of the mysterious white figure, possibly representing Charon, in Arnold Böcklin's *Island of the Dead*?
5 August von Platen (1796–1835), 'Wer die Schönheit geschaut mit Augen / Ist dem Tode schon anheimgegeben', from the poem *Tristan*.

Translated from the German by Catherine Schelbert

Thinking in Pictures

Katharina Fritsch with Susanne Bieber

Susanne Bieber: At Tate Modern you will show your three 'bad' men together for the first time: the *Mönch*, the *Doktor* and the *Händler*. They are very dark, severe figures. Are these works intended to reveal male power structures in our society? **Katharina Fritsch: They are really bad characters and such bad men are unfortunately still in the majority. But if they didn't exist, then I couldn't make those sculptures and that would be boring! (laughs) They are stereotypical characters who have been grotesquely exaggerated but who nevertheless seem somehow cool. These figures have something quietly expressive, something lurking just under the skin: on the outside they seem relaxed, but inside they are seething. There is a tension that won't go away. I think you can get a shock when you come up against these figures. They show a male attitude that we should be shocked by.** Susanne Bieber: You show the powerful stances that some men in our society like to adopt, but at the same time you undermine them by exaggerating the way they are presented. The men's uniforms also radiate power. **Katharina Fritsch: The monk's habit, the doctor's coat and men's suits are types of clothing that I do find very interesting. Actually these uniforms are standards that always look good. Everyone looks good in them. I find the ambiguity of the power structures that are implied by these 'uniforms' interesting. Clothes are in any case a very fascinating subject that is much neglected. They are only ever looked at from the point of view of fashion and not as uniforms or as standards. It's interesting to see how people present themselves, how their status is reflected in their clothes. In my generation clothes always had to be sexy as a matter of course; I just find that too simplistic and rather boring.**

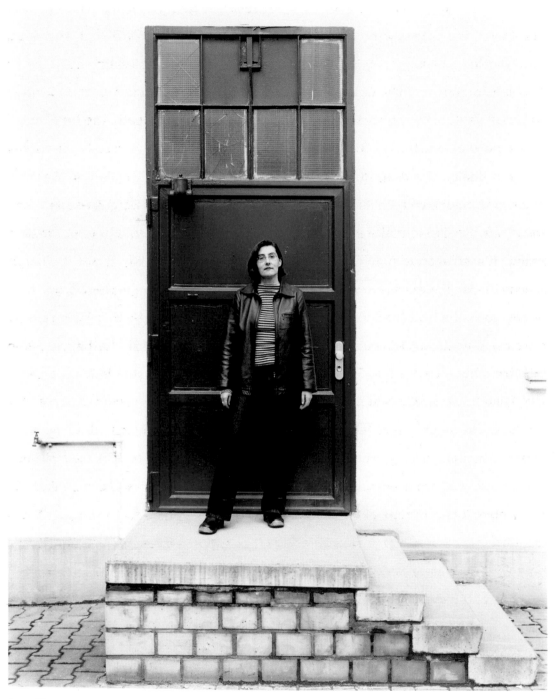

Anna Giese
Portrait of Katja Fritsch, 1999

Susanne Bieber: It seems that you subvert the promises made by different forms of institutional power. The monk and his religion are thought to promise us hope and security, the doctor should be caring for our well-being and the dealer should be selling quality goods.

Katharina Fritsch: Actually the figures do conform to these standard patterns, but to a grotesque degree: the physician who doctors his patients to death, the monk who is holier-than-thou and the dealer who cold-bloodedly rips you off and sells you rubbish; the mean dealer, the drug dealer, is simply called 'dealer' in English. In German a 'dealer' is someone who deals in drugs but in English the same word is used for an art dealer. I always like to make a rather black joke when I tell people that my 'dealer' is coming. It's so wonderfully ambiguous, and that's what I like about it. (laughs)

Susanne Bieber: For years now you've been concerned with equal rights for women, but up until now you haven't really addressed that as a theme in your work. Do your feelings regarding women's rights come more to the fore in your new sculptures? **Katharina Fritsch: That's true, but I always had Frank – a man – as a model. He stands for the generic 'man'. I like to work with him because he is a good model. Men have women as their models, so obviously I have men as my models. They are my muses.** Susanne Bieber: The female model is usually exposed to the male, sexual gaze. In your work the male model doesn't seem to turn into a sexual object. **Katharina Fritsch: I don't want to be that obvious. I wouldn't photograph stark naked men. It would be much too boring, and in any case there are already so many pictures like that. Eroticism lies in those subtle areas where you think there isn't anything and then there is something after all. I'm much more interested in those little in-between games.** Susanne Bieber: Besides the three men, you're also working on a new display stand at the moment, where you are combining a number of new multiples like the skull and the brain, the heart made from red teeth …

Katharina Fritsch: … a fly that I like very much, praying hands, a black snake,

a translucent, sharp green cross, a cat, a little black poison bottle and a rat-king sitting on the lowest shelf. It's mostly in black and white and it has just two highlights of colour, the red heart and the poisonous green cross. Susanne Bieber: Is the new *Warengestell* a companion piece to the first one? That one was colourful and full of life, this one is black-and-white and sombre, just like a memento mori. **Katharina Fritsch: I made my first *Warengestell* when I was still very young, twenty-six or twenty-seven. It is full of life, it's even a bit erotic with the flowers and the red pearls. Now I am forty-five, half way through life and at this age you have to show the other version. At my age one is much more aware of one's own transience. One's parents are getting old; my father died three years ago. I actually experienced the death of other family members very early on, but now at my age one is much closer to it because we are the next generation. The consciousness of mortality and of the possibility of illness is more present at my age than at twenty or thirty, and one starts thinking about how things will turn out. I am not thinking about only these things, but they reflect an aspect of life. Somehow you have to take a position towards these things even if it is hard to deal with them, otherwise you can't go on living.** Susanne Bieber: Many people repress this side of life because there are no simple answers to these difficult questions. But in the end it's not about finding answers but about accepting life in all its different facets. You're dealing with very religious questions. **Katharina Fritsch: My works do have a religious aspect, but not in the sense of a particular religion. My sculptures can never be totally grasped, like a picture that has something unresolved about it. They stay in your head like an enigma. That's how life seems to me and that's how I depict it. I think you could call that a religious attitude, although I hope not of the finger-wagging kind. It's simply a recognition of the fact that life is ambivalent.** Susanne Bieber: It is astonishing that this ungraspable quality in your work is not expressed through abstraction, but takes a figurative form.

The multiples on the display stand – like the poison bottle or the fly – are recognisable objects. **Katharina Fritsch: I have always had an urge to be pictorial. These objects are like particular stories that you can use to convey things that can otherwise not be grasped.** Susanne Bieber: Do you think that the return to figuration has its roots in the *Zeitgeist* of the 1980s? **Katharina Fritsch: I think this reaction to abstract painting is typical of the generation that was born in the 1950s. In my case this reaction wasn't carefully considered. When I arrived at the academy I wanted to make really old-fashioned pictures with figures in them. I made objects such as *Dunkelgrüner Tunnel* (*Dark Green Tunnel*, 1979) and *Besen* (*Broom*, 1979). In those days that struck everyone as unspeakably amusing, particularly since Minimal art was so dominant. But it meant that as soon as people saw my work at the annual Academy show they noticed it and found it exciting and special.** Susanne Bieber: Your representational sculptures have an expansive and visual presence, and engrave themselves in the viewer's memory. Anyone who has seen *Elefant*, *Mönch* or *Tischgesellschaft* even just once will always remember them. They are powerful, impressive images yet still they have a transience and immateriality. **Katharina Fritsch: Many of my sculptures first exist as an immaterial picture that suddenly emerges in my mind's eye. It's like a vision, a picture that just appears.**

Die Nanis und Käfi (The Nanis and Käfi), 2001

I think in pictures. I once had an assistant who claimed that was not possible, but perhaps I am an exception, I really can think in pictures. It's important that my sculptures don't have that 'heavy metal' feeling. I am less concerned with sculpture than with the third dimension. Of course I have to abide by all the various laws of sculpture but actually I would like to forget these and just make three-dimensional pictures. That is to say, I go through a process that leads from the original picture to reality, which then turns back into a picture. I find this game between reality and vision very interesting. I think my work moves backwards and forwards between these two poles. There is still the connection to the real, but at the same time to the unreal. Susanne Bieber: At the same time as we are showing your work at Tate Modern there will also be a large exhibition of Surrealist work. Do you see any connection between your work and Surrealism? **Katharina Fritsch: I think that I was very much influenced by Surrealism but that I have gone a stage beyond it towards reality. I feel a close affinity with the magical quality of Surrealism. But for me the purely psychological explanation of the Surrealists is not enough.** Susanne Bieber: So you see the 'miraculous in the real', to quote Alejo Carpentier, the creator of 'magic realism', whose writing integrates elements from dreams, magic and religion into a particular concept of reality. **Katharina Fritsch: Yes, my works have a similar dimension – a sense of not being able to grasp something. I find the same thing in my own life, that I can't always grasp everything. You can call it magic but it's also perfectly real. In the magazine** *Spiegel* **there was an article just recently on mental hallucinations, for example when you think you are encountering your doppelgänger. That is actually a sign of certain mental illnesses like schizophrenia. In** *Tischgesellschaft*, **for instance, I was thinking of such illnesses, of drugs and madness, also of false perceptions. The work is like a** *weltträtsel*, **a big puzzle of the world. The man is brooding over the table cloth with a meandering pattern on it that will never make sense. He is sitting**

at the table with his friends, but they are all himself. He is caught up in himself and thinks in circles; he is completely withdrawn. The work also shows the individual's fear of somehow dissolving, the anxiety that he might have been cloned. It's a work about fear. I sometimes like sending a few shivers up people's spines. Susanne Bieber: In that work you combine fascination and fear, like in a horror film: the audience is terrified and yet at the same time so fascinated that they go on looking and can't get away from it. In *Gespenst und Blutlache* a non-corporeal being is represented as a tangible thing in space. **Katharina Fritsch: The ghost is a being that no one has ever yet seen. Why should a ghost look like that? We actually have no idea what they look like. I find it interesting that in this work I have made something real that doesn't in fact exist. At the same time it could just be someone with a sheet draped over them. I also had a good time 'faking' the pool of blood, which has a really creepy, unreal quality.** Susanne Bieber: Is it the materiality of your sculptures that allows them to oscillate between the real and the unreal? **Katharina Fritsch: The materiality disappears in my works and is not important – of course it is important, in the sense that it has to create precisely this effect of non-materiality. The way the surface is finished plays a significant part in this – the colours have to be chosen very exactly. Often my sculptures have a matt surface so that there is no reflection whatsoever from the surroundings. That increases the impression of a vision that one cannot grasp.** Susanne Bieber: In the case of the *Mönch*, he just seems like a deep black hole … **Katharina Fritsch: He completely absorbs any light. The *Mönch* represents something depressive where everything is sucked inwards. For me this false monk is an utterly inhibited person, looking downwards and adopting a holier-than-thou attitude.** Susanne Bieber: On the other hand, you are also interested in gleaming surfaces. I'm thinking of the early multiples on the first display stand, such as *Doppelseitiger Spiegel* (*Double-Sided Mirror*, 1981), or *Edelstein* (*Precious Stone*,

1983). And in your new works as well, for instance the hearts … **Katharina Fritsch: That's true. Sometimes I include a certain amount of reflection, like in the picture frames or the *Stern* (*Star*, 1983/93). The surface looks metallic and works like a blind mirror. *Herz mit Geld und Herz mit Ähren* (*Heart with Money and Heart with Wheat*, 1999) has to shimmer. This floor sculpture has a very rigorous outer contour but, because of the way the light reflects on the gleaming elements, the work shimmers and twinkles in thousands of colours like the surface of water. It has a magnetism all of its own. When I first laid out *Herz mit Geld* in New York, I thought it was completely banal. But when it was lying finished on the floor it had the same effect as the figures, being there and yet not there. As a child I was always fascinated by the fairy tales where someone was given a task. In the Grimm Brothers' story 'The Peasant's Wise Daughter', she is set a challenge: 'She was … obliged to appear before the king, who asked her if she really was so wise, and said he would set her a riddle, and if she could guess that, he would marry her. She at once said yes, she would guess it. Then said the king, come to me not clothed, not naked, not riding, not walking, not in the road, and not off the road, and if you can do that I will marry you.'[1] This existing yet not existing is part of my work.**

Susanne Bieber: When one looks at your sculptures one might think that you had made them by magic in a fraction of a second. That first impression gives no hint of the painstaking process behind the work. **Katharina Fritsch: The work involved is really immense, but that is the fate of sculptors who make representational objects. I work very precisely and that takes a lot of time. I need people who work very exactly and who know how to manipulate the material when modelling.** Susanne Bieber: When you have the picture of a sculpture in your mind, for instance the *Mönch*, what are the first steps you take when it comes to realising the tangible sculpture? **Katharina Fritsch: In the case of the *Mönch* I first had to do a certain amount of research. What kind of monks' habits are there? Are**

there in fact any monks like the one I have in mind? This one's habit is a mixture of Benedictine and Franciscan but apparently there is an order that wears habits like this. The Franciscans have a pointed hood, but I wanted a rounded one. I think about what the collar should look like, how many knots the waist cord should have and what thickness it should be. The *Mönch*'s habit was made by a friend of mine. Frank, my model, was then called into the studio and he had to put on the habit. He had to hold his hands first this way and then that way and take up different positions. Susanne Bieber: Do you make sketches at this stage, either of details of the habit or of Frank posing as the monk? Katharina Fritsch: No, I take photographs. They're usually bad photos, but that doesn't matter. They are only used as a record of Frank in the habit in the right

position. Then the day came when we made the mould. First of all I went to the barber with Frank so that he would have the right hair-cut. Then we covered him entirely in Vaseline to protect him and we made a plaster mould of his head and his hands. And all the time Frank had to put up with my tetchy instructions, telling him not to move and that he was only allowed to look down. (laughs) But he was very patient and did it really well. At these moments he is really an actor, in any case he is a musician. It seems to me – and that's also why I like working with him as a model – that he can adopt a

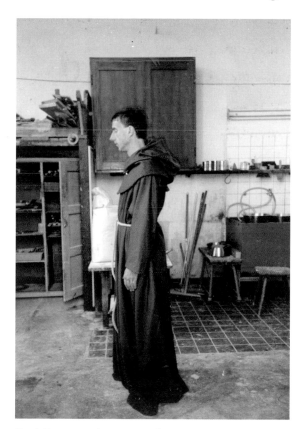

Frank Fenstermacher as a monk, 1999

overleaf: *Herz mit Geld und Herz mit Ähren* (*Heart with Money and Heart with Wheat*), 1998–9
Plastic, aluminium, paint
800 × 400 × 4 cm (312 × 156 × 1 ½ in)

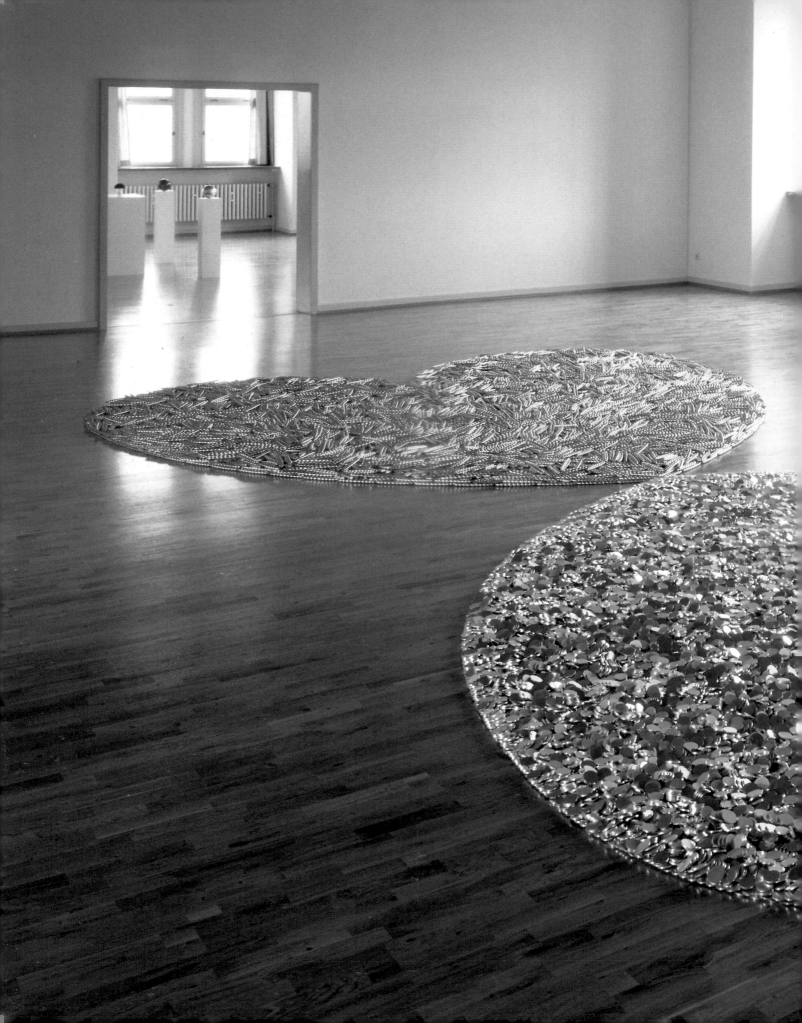

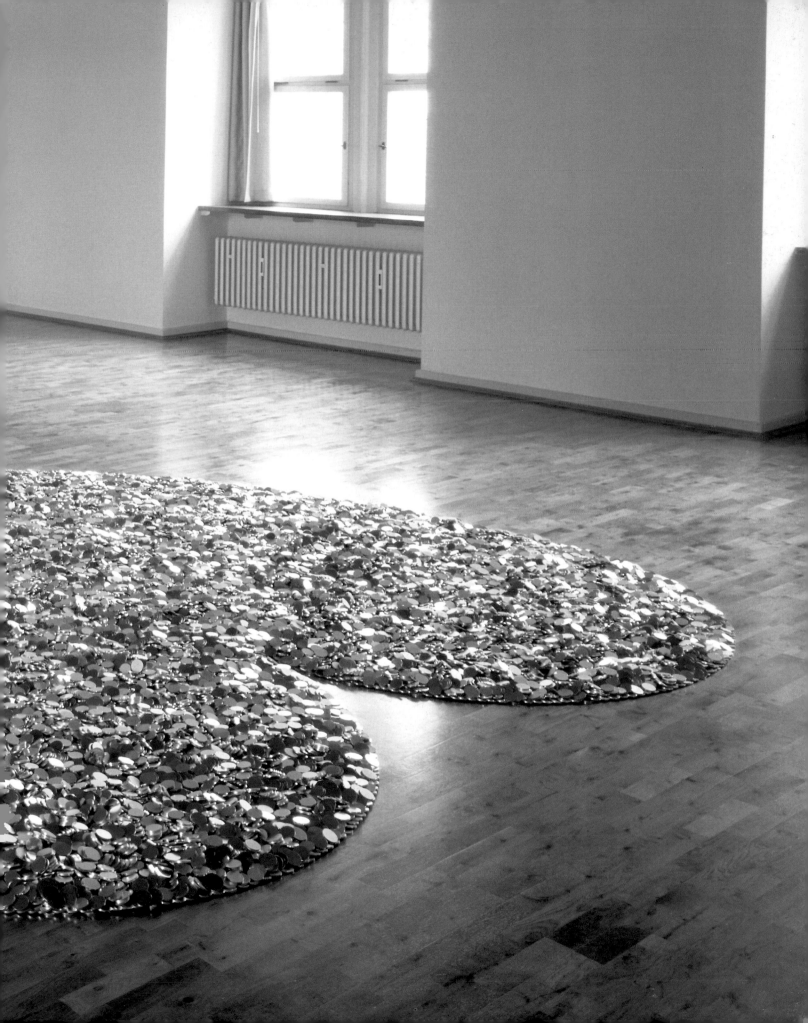

particular character without too much trouble. I say to him, look down and look pious and he does just that! Susanne Bieber: It's interesting that you use the same model for so many of your sculptures. Frank is the model for *Mann und Maus*, for *Tischgesellschaft*, for the *Händler* and for the *Mönch*. He is like a chameleon who can turn into all sorts of personalities. **Katharina Fritsch: Yes, he has an incredible ability to change; he can alter his expression with a minimum of effort, and he does it without losing himself. He always maintains a certain distance to his role.** Susanne Bieber: Do you generally work for relatively long periods with the same people who know your work and who know exactly what you want? **Katharina Fritsch: Some have been there for a long time, but here are also a lot of changes. At the moment I have three or four assistants and a plaster technician. I could certainly do with more. Of course I have been working with Frank for a long time now. The plaster technicians also have a very important role. It's absolutely essential that they know what I want. They are involved in the technical process right from the outset.** Susanne Bieber: So first there is the plaster negative … Katharina Fritsch: … **which is always very interesting. I find it exciting, making moulds. It's a great form to be working with, because you can see the positive form in the negative. This negative-positive relationship has something mysterious about it which fascinates me.** Susanne Bieber: The negative form shows something that isn't there, something that cannot be grasped, like a shadow or like tracks in the sand. This ungraspable quality can also be found in the content of your works. **Katharina Fritsch: Yes, in terms of form, sculpture is about a positive-negative relationship, but you can apply the same thing to moral values too. Form and content play into each other and together form an entity. The plaster technician makes a positive form from the negative and this makes the head and the hands. These forms have to be worked over, but that is usually done pretty quickly. Of course the whole-body casts are**

difficult. We once did that with Frank at a table and he nearly died. He wasn't getting enough air because he had too much plaster on his skin and we had impregnated his clothes as well. His skin couldn't breathe any more and inside the layer of plaster Frank was turning blue and suddenly his head lolled forwards. I thought we should take the plaster form off him, but the plaster technician didn't want to ruin the form. But I insisted and we barely saved Frank. From that day on we called the plaster technician the White Hangman … Susanne Bieber: Frank does have to put up with a fair amount … **Katharina Fritsch: Yes, poor thing. (laughs) Since then I make whole-body casts only from a mannequin. For the *Mönch* we took a cast from the mannequin**

Negative plaster of Paris forms

wearing the habit. We put all the plaster casts together and we had a kind of scarecrow from which to create the figure of the *Mönch*. It's that very old-fashioned kind of plaster modelling: applying it, taking it away, applying it, taking it away and so on. Susanne Bieber: So the negative cast is made from plaster, the positive form is also plaster, and the changes you make on that are also in plaster? **Katharina Fritsch: Exactly, the whole thing is worked in plaster. Plaster is a really wonderful material; firstly it is very exact, secondly it has a certain resistance when you are working with it with the result that it holds shapes very well. With a soft material like clay it's quite different. You can only mess around with it; I find working in clay really awful. It's also important that you have someone who is an expert in modelling with plaster, so that every surface holds its shape and every surface sits as it should. It's really important for me that the whole figure becomes my own from top to toe, that every centimetre has been resolved, that there aren't bits here and there that take on a life of their own and aren't necessary, like wrinkles that are purely arbitrary. You have to observe the laws that govern sculpture, the forms have to be coherent, the figure that emerges must be worked out properly and with clarity. I like to think that I am not too bad at that.** Susanne Bieber: Do you also use mathematical rules to calculate the figures? For example do you use the Golden Section, or do you rely more on intuition? **Katharina Fritsch: No, I've never consciously used the Golden Section as a guide. But of course we do measure the figures. I start with certain proportions in mind, but you can't only depend entirely on mathematics. Take the rats from *Rattenkönig*, for example: they started very small but when we blew them up very big we found hamsters sitting in front of us. The perspective changes completely when you enlarge a figure. The head was huge and it had a tiny little behind because it stretches back four whole metres. We couldn't keep the original proportions.** Susanne Bieber: In this instance you had made a model for the piece? **Katha-**

rina Fritsch: Yes, a small one, too small. We should have made an intermediate model. It was trial and error and you learn from that. Of course these same laws also apply to figures in churches, which is why the figures were made larger at the top. But unfortunately I don't know nearly enough about that. Probably there are also ways of calculating that, but I don't know how it is done. I just use my eyes, that's quicker. Susanne Bieber: And what then happens when the modelling with plaster is finished? **Katharina Fritsch: That process usually takes a very long time because I constantly have to look at it, make changes, stand back and look at it again. Then a negative form is made from the model out of silicon and after that a positive form in polyester. Usually we**

Dusty and Friends, 2001

have several sections which have to be put together and then worked over again. That takes a great deal of time because the surface has to be absolutely perfect. Susanne Bieber: And then last of all comes the layer of paint, which is very important for the 'immaterial' look of your sculptures? Katharina Fritsch: Yes, thenI paint the sculpture or spray it, but that isn't so much work. The worst thing is the endless modelling in plaster. I put myself through agonies when I'm doing that, wondering about the length of the arms or how the hands should sit on the body. I can drive myself crazy over a matter of a few centimetres. Everything has to be right. Susanne Bieber: How long does the whole process last? Katharina Fritsch: That varies. Some sculptures work very easily, others have to be constantly changed. It took almost two months before I had the monk's hood so that it just looked like a hood. You're almost finished and then you come to the hood and you can get completely stuck at a detail like that. It just always looked wrong. And I can't just use magic, it has to come of its own accord. Altogether I spent about a year working on the *Mönch*. Susanne Bieber: In your sculptures you use different materials; besides plaster and polyester you also use aluminium, wood, foil, varnish and so on. Do you decide on a particular material at the outset or does that emerge during the course of the work? Katharina Fritsch: At the beginning I generally have a fairly good idea of the material I want to use. But of course that can change during the working process. For the coins, for instance, I initially had aluminium in mind, because of its silvery sheen and because you can anodise it. The coins could be easily stamped out of aluminium. I thought to myself, so you'll be doing something really quickly for a change, but this particular work has taken the longest so far. The thing was that I had already commissioned a whole series of aluminium coins and had paid for them, when one evening I started wondering if the coins should be two millimetres thicker – oh no! (sighs) I tried it out and the thicker coins looked much better. So I had to make

*Herz mit Ähren (**Heart with Wheat**)*, 1999 (detail)
Plastic, aluminium, paint
400 × 400 × 4 cm (156 × 156 × 1 ½ in)

them in a synthetic material instead of in aluminium. First we had to make a metal form and then the coins had to be injection-moulded, given a metallic lustre and then varnished. In the end I felt this process worked much better. The results are more pictorial and the contours are more precise than if they had been stamped because the corners don't get pressed down. But it involves a lot of separate processes that are very time-consuming and very expensive. Susanne Bieber: The material, technique and content of your work form a kind of symbiosis and each aspect is essential in the realisation of the whole. I imagine you must be very aware of the possibilities and limitations of the individual materials? Katharina Fritsch: Experience tells me that if things are not technically possible then something about the form has not been properly thought out. It's

Claudia van Koolwijk
Katja Fritsch, 1981

interesting: one has to observe certain standards but one should not become a slave to them. That is also a very important aspect of my work – I have to perform a balancing act, between the 'real' which is possible and the 'vision' of what one might make. I try to go to the limits of what is technically possible. I think that many artists want to go beyond those limits, and then they fail because they're trying to do things that haven't been properly thought out. Although I'm certainly not of the opinion that one should set limitations for oneself from the outset and should only think in terms

of what is possible, absolutely not. Susanne Bieber: *Herz mit Geld* was made at the same time as *Herz mit Ähren*. Did the wheat ears cause just as much trouble? **Katharina Fritsch: The ears had to match the coins, and they too were much too small. I made them about ten times in different sizes. In the end I put everything on the photocopier and copied the ears so that I could imagine a whole array of them in different sizes. I make a lot of models out of cardboard; that way I was able to decide on the correct size.** Susanne Bieber: You commission manufacturers to produce things like the ears of corn or the coins or other multiples? **Katharina Fritsch: There are multiples that are not made in-house, but by manufacturers, like *Vase mit Schiff*, or extruded forms like the ears of wheat or the coins. But these manufacturers don't always work the way one wants them to. Thousands of difficulties crop up: the items are too thick or they can't be properly separated from the form. You have to take into account all sorts of technical problems. Art historians often don't understand the meticulous and finicky nature of this work. Sometimes the multiples are made by hand in my own studio. The *Madonnenfigur*, for example, is cast, painted and finished by hand.** Susanne Bieber: I admire your steadfastness. You never give up until everything is 100 per cent right and that is reflected in the perfection of your sculptures. It's clear that the apparent effortlessness of your works is only achieved by means of a lengthy period of intense work. I assume that the work particularly mounts up towards an exhibition opening. **Katharina Fritsch: That is always unbelievably stressful. Above all if a manufacturer doesn't meet a deadline. But I can't postpone my deadlines and the work has to be ready for the exhibition and it has to be good.** Susanne Bieber: For your exhibition at Tate Modern you made a model of the museum space with miniature versions of your works so that you could see the whole installation. Is an exhibition also a part of your artistic expression? **Katharina Fritsch: Yes, definitely. For me it has to form a unity and I never see an exhibition**

as simply a sequence of works but always as one large picture. It has to be one large-scale composition. It doesn't matter if I'm thinking about just one sculpture or a whole exhibition, ultimately everything has to look completely natural, as though it had been absolutely no trouble, as though it had suddenly just appeared out of the blue.

1 'The Peasant's Wise Daughter', *Grimm's Household Tales*, trans. Margaret Hunt, date unknown; first German edition, 1812

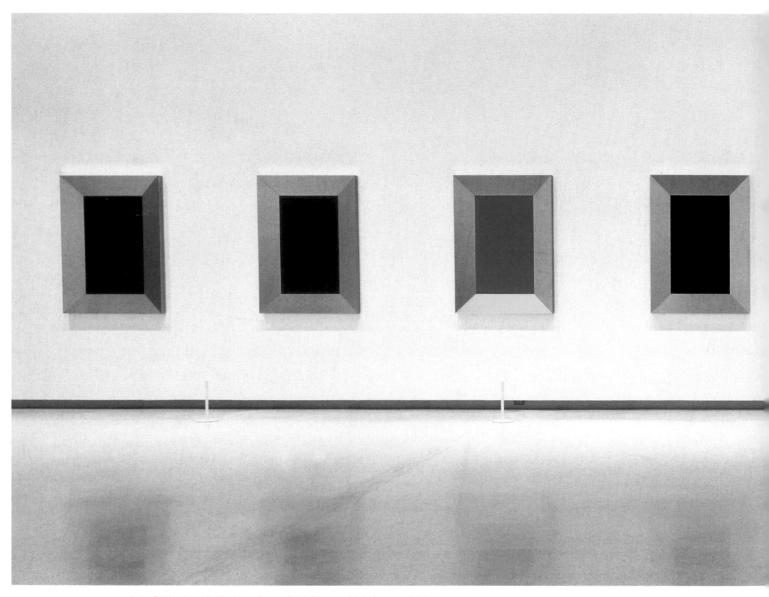

Acht Bilder in acht Farben: Rotes Bild, Blaues Bild, Grünes Bild,
Schwarzes Bild, Weisses Bild, Gelbes Bild, Hellgrünes Bild, Oranges Bild
(*Eight Paintings in Eight Colours: Red Painting, Blue Painting, Green*
Painting, Black Painting, White Painting, Yellow Painting, Light Green
Painting, Orange Painting), 1990–91
Wood, foil, lacquer, untreated cotton cloth, paint
140 × 100 × 8 cm each painting, 140 × 1500 × 8 cm overall
(55⅛ × 39⅜ × 3⅛ in each painting; 55⅛ × 590⅝ × 3⅛ in overall)

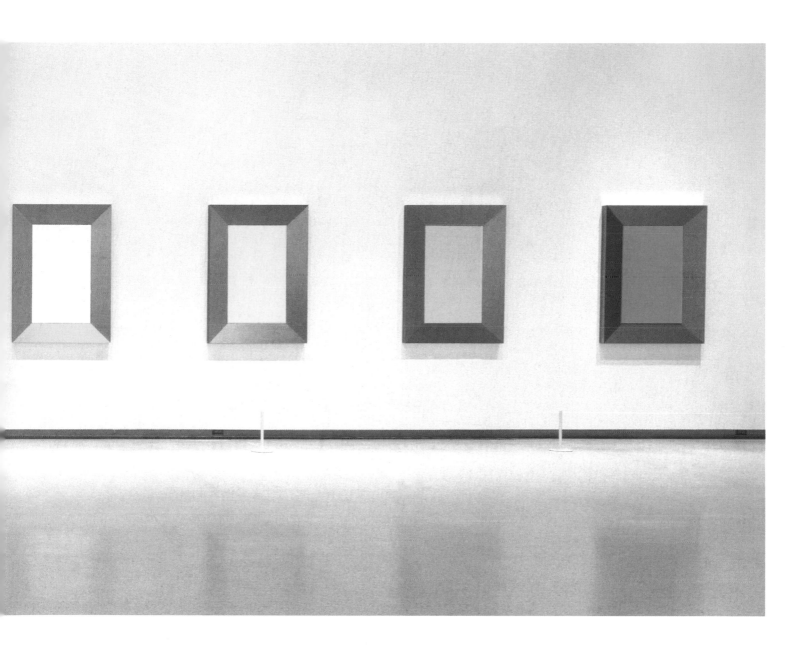

Works in the Exhibition

Display Stand (Warengestell)
1979–84
Glass, aluminium, objects dating
from 1979–84
Diameter 120 cm, height 203 cm
(diameter 47¼ in, height 79¹⁵⁄₁₆ in)
Lender: Kaiser Wilhelm Museum,
Krefeld

Messekoje mit Vier Figuren
(*Trade Fair Stand with Four Figures*)
1985/6/2001
Wood, paint, plaster of Paris
200 × 200 × 280 cm
(78¾ × 78¾ × 110¼ in)
Lender: Katharina Fritsch, Düsseldorf

Elefant (Elephant)
1987
Polyester, wood, paint
380 × 160 × 420 cm
(149⅝ × 63 × 165⅜ in)
Lender: Katharina Fritsch, Düsseldorf

Warengestell mit Madonnen
(*Display Stand with Madonnas*)
1987/9
Aluminum, plaster of Paris, paint
Diameter 82 cm, height 270 cm
(diameter 32⁵⁄₁₆ in, height 106⁵⁄₁₆ in)
Lender: Staatsgalerie, Stuttgart

Warengestell mit Vasen
(*Display Stand with Vases*)
1987/9/2001
Alumninum, plastic, silkscreen print
127 × 127 × 270 cm
(50 × 50 × 108 in)
Lender: Katharina Fritsch, Düsseldorf
Courtesy: Matthew Marks Gallery,
New York

Tischgesellschaft
(*Company at Table*)
1988
Polyester, wood, cotton, paint
1600 × 175 × 150 cm
(629¹⁵⁄₁₆ × 68⅞ × 59 in)
Lender: Museum für Moderne Kunst,
Frankfurt am Main, on permanent loan
from Dresdner Bank

Gespenst und Blutlache
(*Ghost and Pool of Blood*)
1988
Polyester, paint, lacquer, Plexiglas
Ghost, 60 × 60 × 200 cm
(23⅝ × 23⅝ × 78¾ in)
Pool of blood, 53.2 × 209.4 cm
(20¹⁵⁄₁₆ × 82⁷⁄₁₆ in)
Lender: Daros Collection, Zurich

Krankenwagen (Ambulance)
1990
Single (7-inch vinyl record)
Lender: Katharina Fritsch, Düsseldorf

Acht Bilder in Acht Farben
(*Eight Paintings in Eight Colours*)
1990–1
Wood, foil, lacquer, untreated
cotton cloth, paint
140 × 100 × 8 cm each;
140 × 1500 × 8 cm overall
(55⅛ × 39⅜ × 3⅜ in each;
55⅛ × 590⅝ × 3⅜ in overall)
Lender: Katharina Fritsch, Düsseldorf

Mann und Maus (Man and Mouse)
1991–2
Polyester, paint
225 × 130 × 240 cm
(88⁹⁄₁₆ × 51³⁄₁₆ × 94½ in)
Lender: Sammlung Ackermans, Xanten

Kind mit Pudeln
(*Child with Poodles*)
1995–6
Plaster of Paris, foil,
polyurethane, paint
Diameter 512 cm, height 40 cm (diam-
eter 201⁹⁄₁₆ in, height 15½ in)
Lender: Emanuel Hoffmann-Stiftung,
on permanent loan to the Museum
für Gegenwartskunst, Basel

4. Serie Aberglaube – Lexikonzeichnungen (4th Series Superstition – Lexicon Drawings)
1996
Silkscreen print, paper, wood, foil
4 framed silkscreen prints 74 × 52 × 2 cm each (29⅛ × 20½ × ¹³⁄₁₆ in each)
Lender: Katharina Fritsch, Düsseldorf

6. Serie Volksfeste – Lexikonzeichnung (6th Series Public Festival – Lexicon Drawings)
1996
Silkscreen print, paper, wood, foil
4 framed silkscreen prints 64 × 74 × 2 cm each (25³⁄₁₆ × 29¹⁵⁄₁₆ × ¹³⁄₁₆ in each)
Lender: Katharina Fritsch, Düsseldorf

7. Serie Familienfeste – Lexikonzeichnung (7th Series Celebrations Lexicon Drawings)
1996
Silkscreen print, paper, wood, foil
4 framed silkscreen prints 54 × 61 × 2 cm each (21½ × 24 × ¹³⁄₁₆ in each)
Lender: Katharina Fritsch, Düsseldorf

Lexikonzeichnung Weihnachten (Lexicon Drawing Christmas)
1996
Silkscreen print, paper, wood, foil
64 × 84 × 2 cm (25³⁄₁₆ × 33 × ¹³⁄₁₆ in)
Lender: Katharina Fritsch, Düsseldorf

Hexenhaus und Pilz mit Vier Kugeln (Witch's House and Mushroom with Four Balls)
1999
Wood, plastic, paint, aluminium
Witch's house, 40 × 35 × 80 cm (15½ × 13⅞ × 31½ in)
Mushroom, diameter 12 cm, height 15 cm
(diameter 4¾ in, height 5⅞ in)
Balls, diameter 15 cm
(diameter 5⅞ in)
Lender: Städtische Galerie, Wolfsburg

Doktor (Doctor)
1999
Polyester, paint
37 × 56 × 192 cm (14½ × 22 × 75¼ in)
Lender: Sammlung Ackermans, Xanten

Herz mit Geld und Herz mit Ähren (Heart with Money and Heart with Wheat)
1999
Plastic, aluminum, paint
800 × 400 × 4 cm (312 × 156 × 1½ in)
Lender: Katharina Fritsch, Düsseldorf
Courtesy: Matthew Marks Gallery, New York

Mönch (Monk)
1999
Polyester, paint
63 × 46 × 192 cm
(× 24¾ × 18⅛ × 75⅝ in)
Lender: Sammlung Ackermans, Xanten

Händler (Dealer)
2001
Polyester, paint
40 × 59 × 192 cm
(18⅛ × 24¾ × 75⅝ in)
Lender: Katharina Fritsch, Düsseldorf
Courtesy: Matthew Marks Gallery, New York

Warengestell II (Display Stand II)
2001
Glass, aluminium, objects dating from 1981–2001
Diameter 120 cm, height 203 cm
(diameter 47¼ in, height 79¹⁵⁄₁₆ in)
Lender: Katharina Fritsch, Düsseldorf
Courtesy: Matthew Marks Gallery, New York

Katharina Fritsch

1956 born in Essen, Germany.
1977–84 Kunstakademie, Düsseldorf.
Completed advanced studies in 1981
after studying with Fritz Schwegler.
Currently lives and works in Düsseldorf.

Solo Exhibitions
1984 Galerie Rüdiger Schöttle, Munich
(with Thomas Ruff)
1985 Galerie Johnen & Schöttle, Cologne
1987 Kaiser Wilhelm Museum, Krefeld
1988 Kunsthalle, Basel
Institute of Contemporary Arts, London
1989 Westfälischer Kunstverein, Münster
Portikus, Frankfurt
1993 Dia Center for the Arts, New York
1994 Galerie Ghislaine Hussenot, Paris
1995 Venice Biennale, German Pavilion (with
Martin Honert and Thomas Ruff)
1996 Matthew Marks Gallery, New York
Museum of Modern Art, San Francisco
Ludwigforum, Aachen
1997 Museum für Gegenwartskunst, Basel
1999 'Damenwahl' (with Alexej Koschkarow),
Kunsthalle, Düsseldorf
White Cube, London
Städtische Galerie, Wolfsburg
2000 Matthew Marks Gallery, New York
'Multiples', Kunstforum Bâloise, Basel
2001 Museum of Contemporary Art, Chicago

Selected Group Exhibitions
1982 'Möbel perdu', Museum für Kunst und
Gewerbe, Hamburg
1984 'von hier aus', Messegelände (Halle 13),
Düsseldorf
1985 Galerie Schneider, Constance
1986 'von Raum zu Raum', Kunstverein,
Hamburg
'Sonsbeek '86', Arnheim
'Aus den Anfängen', Stiftung Kunstfonds, Bonn
'Europa/Amerika', Museum Ludwig, Cologne
'Junge Rheinische Kunst', Galerie Schipka, Sofia
'A Distanced View'', New Museum of
Contemporary Art, New York
1987 'Hacen lo que quieren. Arte joven renano',
Museo de Arte Contemporáneo, Seville
'Anderer Leute Kunst', Museum Haus Lange,
Krefeld
'Skulptur Projekte Münster', Münster
'Bestiarium', Galerie Rüdiger Schöttle, Munich
'Multiples', Galerie Daniel Buchholz, Cologne
Ydessa Gallery, Toronto
1988 'Cultural Geometry', Deste Foundation
for Contemporary Art, Athens
'Katharina Fritsch, Michael van Ofen, Jeff Wall –
Krieg, Liebe, Geld', Galerie Johnen & Schöttle,
Cologne
Sydney Biennale, Sydney
'Carnegie International', Carnegie Museum
of Art, Pittsburgh
'Nature Morte', Galerie Philomene Magers,
Bonn

1989 Stichting De Appel, Amsterdam
'What is Contemporary Art?', Rooseum, Malmö
'German Art of the Late '80s', Contemporary
Arts Museum, Houston
Galerie Ghislaine Hussenot, Paris
1990 'New Work: A New Generation',
Museum of Modern Art, San Francisco
'Culture and Commentary: An Eighties
Perspective', Hirshhorn Museum and
Sculpture Garden, Smithsonian Institution,
Washington, DC
'Weitersehen 1980–1990', Museum Haus
Esters/Haus Lange, Krefeld
'Hanne Darboven, Walter Dahn, Katharina
Fritsch, Reinhard Mucha, Rosemarie Trockel',
Barbara Gladstone Gallery, New York
'Objectives: The New Sculpture', Newport
Harbor Museum, Newport Beach
'Colour and/or Monochrome', National Museum
of Modern Art, Tokyo
1991 'Metropolis', Martin Gropius Bau, Berlin
'Carnegie International', Carnegie Museum
of Art, Pittsburgh
'In anderen Räumen', Museum Haus Esters/
Haus Lange, Krefeld
'Standpunkt der Moderne. Von Picasso bis
Clemente: Werke aus der Emanuel Hoffmann-
Stiftung Basel', Deichtorhallen, Hamburg
Luhring Augustine Gallery, New York
'Skulpturen für Krefeld 2', Kaiser Wilhelm
Museum, Krefeld
'Contemporary Art from the Collection of
Jason Rubell', Duke University Museum of Art,
Durham, North Carolina
'L'esplai i la idea. Selecció d'obres de la
collecció d'art contemporani Fundació
"La Caixa"', Barcelona (travelled 1989–93)
1992 'Doubletake: Collective Memory &

Current Art', Hayward Gallery, London
(travelled to Kunsthalle, Vienna)
'7: Thomas Bernstein, Günther Förg, Katharina
Fritsch, Isa Genzken, Hubert Kiecol, Wilhelm
Mundt', Galeria Zacheta, Warsaw
'Oh! Cet écho!', Centre Culturel Suisse, Paris
'Ars Pro Domo: Zeitgenössische Kunst aus
Kölner Privatbesitz', Museum Ludwig, Cologne
'Tropismes: Collección Fundació "la Caixa"',
Centre Cultural de la Fundació Caixa de
Pensions, Barcelona
1993 'Lieux de la vie moderne', Centre d'Art
Contemporain, Quimper
'Moving', Stichting De Appel, Amsterdam
'Hotel Carlton Place Chambre 763', Hotel
Carlton Palace, Paris
1994 'Power Works', Museum of New Zealand,
Wellington
'Junge deutsche Kunst der 90er Jahre aus
NRW', Sonje Museum of Contemporary Art,
Kyongju, Korea (travelled to Hong-Kong,
Peking, Taipei, Osaka)
'Meme si c'est la nuit', capc Musée d'Art
Contemporain, Bordeaux
'Zimmer, in denen die Zeit nicht zählt.
Sammlung Udo und Anette Brandhorst',
Museum für Gegenwartskunst, Basel
'en miniature. Malerei und Skulptur', Galerie
Schönewald und Beuse, Krefeld
'Das Jahrhundert des Multiple', Deichtorhallen,
Hamburg
'seeing the unseen', 30 Shepherdess Walk,
London
'Aura', Wiener Secession, Vienna
'Arca de Noã/Noah's Ark: Works from the
Collections of the capc Musée de Bordeaux
and the frac Aquitaine', Fundação de
Serralves, Porto

1995 'Leiblicher Logos', Institut für Auslandsbeziehungen, Stuttgart (travelled to Staatsgalerie, Stuttgart; Altes Museum, Berlin)
'Micromegas', American Center, Paris (travelled to Israel Museum, Jerusalem)
'Zeichen & Wunder', Kunsthaus, Zurich
'Segnos & Milagros', Centro Galego de Arte Contemporánea, Santiago de Compostela
'Sleeper', Museum of Contemporary Art, San Diego
1996 'Everything That's Interesting Is New: The Dakis Joannou Collection', Athens School of Fine Arts; the factory, Athens (travelled to Museum of Modern Art, Copenhagen; Guggenheim Museum Soho, New York)
'Thinking Print', The Museum of Modern Art, New York
'Collections du Castello di Rivoli', Nouveau Musée/Institut d'Art Contemporain, Villeurbanne
'En helvetes förvandling – Tysk konst fran Nordrhein-Westfalen', Kulturhuset, Stockholm
'Stilleben – Nature morte. Natura Morta – Still Life', Helmhaus, Zurich
1997 'Pro Lidice', National Museum, Prague
'Die Sammlung der Dresdner Bank, Frankfurt', Dresdner Bank, Frankfurt
'Die Epoche der Moderne. Kunst im 20. Jahrhundert', Martin Gropius Bau, Berlin
'On the Edge. Contemporary Art from the Werner and Elaine Dannheisser Collection', The Museum of Modern Art, New York
'Miniaturen heute – today – aujourd'hui – oggi', Deichtorhallen, Hamburg
'4ème Biennale de Lyon d'art contemporain: l'autre', Lyon
1998 'Maverick', Matthew Marks Gallery, New York

'Artificial. Figuracions contemporänies', Museu d'Art Contemporani, Barcelona
'Eight People from Europe', Museum of Modern Art, Gunma, Japan
'Hommage à Lidice', Schleswig-Holstein-Haus, Schwerin
'Fast Forward: Trademarks', Kunstverein, Hamburg
'Die Macht des Alters – Strategien der Meisterschaft', Deutsches Historisches Museum/Kronprinzenpalais, Berlin (travelled to Kunstmuseum, Bonn; Galerie der Stadt, Stuttgart)
'Artist's Proof – künstlerisch erprobt', Kaiser Wilhelm Museum, Krefeld (travelled to Kunsthalle, Nuremberg)
'Triennale der Kleinplastik', Stuttgart/Göppingen
'Kunst und Kunststoff', Deutsches Kunststoff Museum, NRW Forum Kultur und Wirtschaft, Düsseldorf
'Auf der Spur. Kunst der 90er Jahre im Spiegel von Schweizer Sammlungen', Kunsthalle, Zurich
1999 'The Eclectic Eye: Selections from the Frederick R. Weisman Collections', California Center of the Arts, Escondido
'Crosscurrents: New Art from MoMA', Hara Museum of Contemporary Art, Tokyo
'The Virginia and Bagley Wright Collection', Seattle Art Museum
'Powder', Aspen Art Museum, Colorado
'dAPERTutto', Venice Biennale
'Pretty, Nice and Fine. Einfach schön', Galerie Schönewald und Beuse, Krefeld
'am horizont', Kaiser Wilhelm Museum, Krefeld
'Romancing the Brain', Pittsburgh Center for the Arts
'Retrace your steps: Remember Tomorrow', Sir John Soane's Museum, London

2000 'Quotidiana. The Continuity of the
Everyday in Twentieth Century Art', Castello
di Rivoli, Turin
'Mensch', Expo 2000, Hanover
'Food for the Mind', Sammlung Udo und Anette
Brandhorst, Staatsgalerie moderner Kunst im
Haus der Kunst, Munich
'figurare', Castello di Rivara
'Kabinett der Zeichnung. Eine Ausstellung des
Kunstfonds', Kunstverein für die Rheinlande und
Westfalen, Düsseldorf (travelled to Kunstverein,
Lingen; Kunstsammlung, Chemnitz;
Württembergischer Kunstverein, Stuttgart)
'Szenenwechsel', Museum für Moderne Kunst,
Frankfurt
'The Intuitive Eye: Selections from the Frederick
R. Weisman Collection', Fashion Institute
of Design and Merchandising, Los Angeles
'ghosts', Delta Axis, Memphis
'Hypermental. Wahnhafte Wirklichkeit
1950–2000 von Salvador Dalí bis Jeff Koons',
Kunsthaus, Zurich (travelled to Kunsthalle,
Hamburg)
2001 'A Contemporary Cabinet of Curiosities.
Selections from the Vicki and Kent Logan
Collection', Californian College of Arts and
Crafts, Oakland
'Und keiner hinkt. 22 Wege vom Schwegler
wegzukommen', Museum Kurhaus, Kleve

Awards
1984 Kunstpreis Rheinische Post
1989 Kunstpreis Glockengasse, Cologne
1994 Coutts & Co. International Award, London
1995 Kunstpreis der Stadt Aachen
1999 Junge Stadt sieht Junge Kunst',
Stadt Wolfsburg

Works in public collections

Canada
Ydessa Hendeles Foundation, Toronto
France
FRAC Aquitaine
CAPC Musée d'Art Moderne, Bordeaux
Germany
Museum für Moderne Kunst, Frankfurt
Museum Kurhaus, Kleve
Kaiser-Wilhelm-Museum, Krefeld
Institut für Auslandsbeziehungen, Stuttgart
Staatsgalerie, Stuttgart
Sammlung Ackermans, Xanten
Städtische Galerie, Wolfsburg
Greece
Deste Foundation for Contemporary Art, Athens
Italy
Castello di Rivoli, Turin
Spain
Caixa de Pensions, Barcelona
Switzerland
Emanuel Hoffmann-Stiftung, Museum für
Gegenwartskunst, Basel
USA
Hirshhorn Museum and Sculpture Garden,
Smithsonian Institution, Washington, DC
Museum of Modern Art, San Francisco
The Art Institute of Chicago
The Museum of Modern Art, New York
The Philadelphia Museum of Art
Walker Art Center, Minneapolis

Selected Bibliography

1983 Fritsch, Katharina, 'Friedhöfe', *Kunstforum International*, No. 65, September
1984 Hecht, Axel, 'von hier aus', *Art*, November
Kraft, Monika, 'Katharina Fritsch', *von hier aus*, exh. cat., Messegelände Halle 13, Düsseldorf
1985 Dank, Ralf, 'Strenge Ordnung. Galerie Johnen & Schöttle zeigt Möbel von Katharina Fritsch', *Kölner Stadtanzeiger*, 28/9 September
1986 *Europa/Amerika*, exh. cat., Museum Ludwig, Cologne
Bos, Saskia, and Jan Brand, 'Katharina Fritsch', *Sonsbeek '86*, exh. cat., Arnheim
Brenson, Michael, 'A Distanced View', *New York Times*, 3 October
Gumpert, Lynn, 'A Distanced View', *Zien*, No. 9
Javault, Patrick, 'Sonsbeek '86', *Art Press*, September
Messler, Norbert, 'Raum und Bildwelt', *Von Raum zu Raum*, exh. cat., Kunstverein, Hamburg
1987 Cooke, Lynne, '"A Distanced View" at the New Museum', *Artscribe*, No. 61, January/February
Heartney, Eleanor, 'Sighted in Münster', *Art in America*, September
Hermes, Manfred, 'Katharina Fritsch. Kaiser-Wilhelm-Museum, Krefeld', *Flash Art*, No. 137, November/December
Heynen, Julian, *Katharina Fritsch. Elefant*, exh. cat., Kaiser Wilhelm Museum, Krefeld
Koether, Jutta, 'Elephant', *Parkett*, No. 13
Wilms, Ulrich, 'Madonna', *Skulptur. Projekte Münster*, exh. cat., Westfälisches Landesmuseum für Kunst und Kulturgeschichte, Cologne
Wulffen, Thomas, 'Statements: Katharina Fritsch', *Kunstforum International*, No. 91, October/November
1988 Ammann, Jean-Christophe, *Katharina Fritsch*, exh. cat., Kunsthalle, Basel, and Institute of Contemporary Arts, London
Archer, Michael, 'Rosemarie Trockel and Katharina Fritsch', *Art Monthly*, November
Blase, Christoph, 'On Katharina Fritsch', *Artscribe*, No. 68, March/April
Christov-Bakargiev, Carolyn, 'Something Nowhere. A Mute Statement of Recent Sculpture Attempts', *Flash Art*, No. 140, May/June
Beyer, Lucie, 'Katharina Fritsch: Kunstverein Münster/Portikus Frankfurt', *Arena*, No. 4
Craddock, Sacha, 'Elegant Twists in a Familiar Yarn', *The Guardian*, 18 November
Godfrey, Tony, 'Report from Germany: A Tale of Four Cities', *Art in America*, November
Koether, Jutta, 'A Report from the field: A question of physical presence', *Flash Art*, No. 141, Summer
Salvioni, Daniela, 'Trockel and Fritsch', *Flash Art*, No. 142, October
Syring, Marie Luise, and Christiane Vielhaber, 'Interview mit Katharina Fritsch', *Binationale, Deutsche Kunst der späten 80er Jahre*, exh. cat., Kunsthalle, Düsseldorf, and Kunstverein für Rheinland und Westfalen, Kunstsammlung NRW, Cologne
1989 Bos, Saskia, 'Topics on Atopy', *De Appel*, No. 2, 1989/90
Cameron, Dan, 'How We Have Changed, Revisited', *Arena*, No. 1
Cottingham, Laura, 'The Feminine De-Mystique', *Flash Art*, No. 147, Summer
Graw, Isabelle, 'Carnegie International', *Galeries Magazine*, December/January

Heynen, Julian, *Katharina Fritsch 1979–1989*, exh. cat., Westfälischer Kunstverein, Münster, and Portikus, Frankfurt

Heymer, Kay, 'Katharina Fritsch. Alles gleichzeitig', *Bremer Kunstpreis*, exh. cat., Kunsthalle, Bremen

Koether, Jutta, 'Katharina Fritsch: Kunstverein Münster/Portikus Frankfurt', *Artscribe*, No. 78, November/December

Magnani, Gregorio, 'This Is Not Conceptual', *Flash Art*, No. 145, April/June

Messler, Norbert, 'Katharina Fritsch at Kunstverein Münster', *Artforum*, October

Suermann, Marie-Theres, 'Katharina Fritsch', *Contemporanea*, No. 9, December

1990 *New Work: A New Generation*, exh. cat., Museum of Modern Art, San Francisco

Weitersehen 1980–1990, exh. cat., Museum Haus Esters/Haus Lange, Krefeld

Objectives: The New Sculpture, exh. cat., Newport Harbor Art Museum, Newport Beach

Cameron, Dan, 'Setting Standards', *Parkett*, 25

Fritsch, Katharina, 'Ich bin Unternehmerin', *Stuttgarter Nachrichten*, 12 December

Garrels, Gary, 'Disarming Perception', *Parkett*, 25

Halbreich, Kathy, 'Katharina Fritsch', *Culture and Commentary: An Eighties Perspective*, exh. cat., Hirshhorn Museum and Sculpture Garden, Smithsonian Institution, Washington, DC

Heynen, Julian, 'Spekulationen über Lastwagen, Friedhöfe, Füchse und andere Bilder', *Parkett* 25

Schmidt-Wulffen, Stephan, 'Katharina Fritsch. Mechanisms of Epiphany', *Objectives: The New Sculpture*, exh. cat., Newport Harbor Art Museum, Newport Beach

1991 *Metropolis*, exh. cat., Martin Gropius Bau, Berlin

Cooke, Lynne, 'Katharina Fritsch', *Carnegie International 1991*, exh. cat., Carnegie Museum of Art, Pittsburgh

Galloway, David, '"Metropolis": Crossroad or Cul-de-Sac?', *Art in America*, July

Heynen, Julian, 'Katharina Fritsch', *Weitersehen 1980–1990*, exh. cat., Kaiser Wilhelm Museum, Krefeld

Strecker, Raimund, 'Weitersehen ohne Fernsicht', *F.A.Z.*, 14 January

Vischer, Theodora, *Katharina Fritsch*, exh. cat., Emanuel Hoffmann-Stiftung Museum für Gegenwartskunst, Basel, and Deichtorhallen, Hamburg

1992 *Tropismes. Colleción Fundació "la Caixa"*, exh. cat., Centre Cultural de la Fundació Caixa de Pensions, Barcelona

Auty, Giles, 'On Our Last Legs', *The Spectator*, 29 February

Cooke, Lynne, 'The Site of Memory', exh. cat., *Doubletake: Collective Memory and Current Art*, Hayward Gallery, London, and Kunsthalle, Vienna

Faust, Gretchen, 'Katharina Fritsch at Luhring Augustine Gallery', *Arts Magazine*, 66, No. 5

Heynen, Julian, 'Mann und Maus', 7: *Thomas Bernstein, Günther Förg, Katharina Fritsch, Isa Genzken, Hubert Kiecol, Wilhelm Mundt, Thomas Schütte*, exh. cat., Galeria Zacheta, Warsaw

Morgan, Stuart, 'Thanks for the Memories. Review of "Doubletake"', *Frieze*, April/May

1993 Ammann, Jean-Christophe, 'Katharina Fritsch', *Bewegung im Kopf. Vom Umgang mit der Kunst*, Lindinger und Schmid, Regensburg

Bobka, Vivian, 'Katharina Fritsch – Immobilizing the Mythical Rat Pack', *Flash Art,* No. 171, Summer

Cooke, Lynne, 'Parerga', *Katharina Fritsch*, exh. cat., DIA Center for the Arts, New York

Larson, Kay, 'Devil's Advocates', *New York Times*, 3 May

Plagens, Peter, 'Invasion of the Rat-King', *Newsweek*, 7 June

Rimanelli, David, 'Katharina Fritsch at DIA', *Artforum*, November

Smith, Roberta, 'German Art Still Breathes the Air of Ideas', *New York Times*, 23 April

1994 *Zimmer in denen die Zeit nicht zählt*, exh. cat., Museum für Gegenwartskunst, Basel

Cramer, Sue, 'Katharina Fritsch', *Power Works from the MCA Collection*, exh. cat., Museum of New Zealand, Wellington

Winzen, Matthias, 'Katharina Fritsch', *Journal of Contemporary Art*, Vol. 7, No. 1

Lauter, Rolf, 'Katharina Fritsch. Das Individuum und die kollektive Angst', *Kunstforum International*, No. 128, October/December

Rhomberg, Kathrin, 'Katharina Fritsch', *Aura*, exh. cat., Wiener Secession, Vienna

Troncy, Eric, 'Katharina Fritsch at Ghislaine Hussenot', *Flash Art*, No. 178, October

Winzen, Matthias, 'Katharina Fritsch – Ein Gespräch', *Das Kunst-Bulletin*, 1/2, January/February

1995 *Sleeper*, exh. cat., Museum of Contemporary Art, San Diego

Zeichen & Wunder, exh. cat., Kunsthaus, Zurich

Ammann, Jean-Christophe, 'Ich stecke gewiss in keiner autistisch-regressiven Phase purer Selbstbespiegelung, Gespräch mit Heinz-Norbert Jocks, *Kunstforum International*,

No. 131, August/October

Couturier, Elizabeth, 'Biennale: les jeux sont faits', *Beaux Arts Magazine*, No. 35, June

Criqui, Jean-Pierre, 'Best of Show', *Artforum*, September

Flemming, Viktoria von, 'Katharina Fritsch: Mythen reichlich im Angebot', *art*, No. 6

Hohmeyer, Jürgen, 'Niedlich, aber fies', *Der Spiegel*, No. 23

Müller, Hans-Joachim, 'Die Zeit, die Kunst, der Stachelbaum', *Die Zeit*, 16 June

Spies, Werner, 'Das rote Desaster', *F.A.Z.*, 10/11 June

1996 *Katharina Fritsch*, exh. cat., Museum of Modern Art, San Francisco, and Museum für Gegenwarskunst, Basel

Karmel, Pepe, 'Katharina Fritsch at Matthew Marks Gallery, NY', *New York Times*, 10 May

Schmidt-Wulffen, Stephan, 'Low Fidelity: Notes on the Work of Katharina Fritsch', *Robert Lehman Lectures on Contemporary Art*, ed. Cooke, Lynne, and Karen Kelly, Dia Center for the Arts, New York

Zonia, Amanda, 'Art that Goes Bump in the Night: Sculptures by Katharina Fritsch', *Artnews*, November

1997 Blase, Christophe, 'L'autre', *Artforum*, October

Boschmann, Hella, 'Maxi-Ratten, minimalistisch', *Die Welt*, 23 January

Jansen, Gregor, 'Siemens-Winzen bietet Damenwahl an', *Blitzreview*, 10 November

Knapp, Gottfried, 'Im Schatten des Rattenkönigs', *Süddeutsche Zeitung*, 28 July

Müller, Hans-Joachim, 'Alles unter Kontrolle, alles im Griff oder vielleicht doch nicht?', *Basler Zeitung*, 26/7 April

Spinelli, Claudia, 'Katharina Fritsch im Museum für Gegenwartskunst', *Das Kunst-Bulletin*, 7/8, July/August

Tanner, Marcia, 'Katharina Fritsch at SFMOMA', *Artweek*, January

Wagner, Thomas, 'Das Märchen vom Warengestell', *F.A.Z.*, 4 June

1998 'Protest: Künstler kämpfen für den Kunstpalast Düsseldorf', *art*, No. 1, January

Attias, Laurie, 'Close to the Edge', *Artnews*, Summer

Grandas, Teresa, 'Katharina Fritsch: *Warengestell mit Madonnen*', *Artificial. Figuracions contemporânies*, Museu d'Art Contemporani, Barcelona

Haenni, Jean-Paul, and Blaise Mulhauser, *Rats*, exh. cat., Muséum d'histoire naturelle, Neuchâtel

Jürgensen, Andreas, *The Mass Ornament. The Mass Phenomenon at the Turn of Millennium*, exh. cat., Kunsthallen Brandts Klaedefabrik, Odense

Wally, Barbara, 'Katharina Fritsch', *Skulptur – Figur – Weiblich*, exh. cat., Landesgalerie Oberösterreich, Linz

1999 *am horizont*, exh. cat., Kaiser Wilhelm Museum, Krefeld

'Ausstellung Katharina Fritsch: "Junge Stadt sieht Junge Kunst"', *indigo*, No. 12

'Ideal-Museum und sein ironisches Gegenstück. Rauminstallationen von Katharina Fritsch und Alexej Koschkarow', *Düsseldorfer Amtsblatt*, 20 February

Katharina Fritsch, ed. Pfleger, Susanne, exh. cat., Städtische Galerie, Wolfsburg

Romancing the Brain, exh. cat., Pittsburgh Center for the Arts

Bianchi, Paolo, 'Venezia (im)possibile.

Künstlerische Öffnung an der Lagune', *Kunstforum International*, No. 147, September/November

Brunn, Vera, 'Installateure im Museum: Die Kunsthalle zeigt das Ideal-Museum von Katharina Fritsch und eine Installation von Alexej Koschkarow', *Prinz*, February

Fischer, Guido, 'Engagement mit Augen-Mass: Katharina Fritsch in der Kunsthalle', *Überblick*, February

Fritsch, Katharina, 'Factory Chimney', *Dreams*, ed. Bonami, Francesco, and Hans Ulrich Obrist, Fondazione Sandretto Re Rebaudengo per l'Arte, Turin

Grosenick, Uta, and Burkhard Riemschneider, *Art at the Turn of the Millennium*, Taschen, Cologne

Haase, Amine, 'Versöhnung der Gegensätze. 48. Biennale von Venedig', *Kunstforum International*, No. 147, September/November

Hirsch, Thomas, 'Katharina Fritsch. Museum im Museum', *Biograph*, March

Hoffmans, Christiane, 'Künstler über die "Macht des Alters"', *Welt am Sonntag*, 7 February

Imdahl, Georg, 'Gymnastik im Lustgarten über dem Tempel', *F.A.Z.*, 24 February

Keul, Andreas, 'Doppelgänger. Repliken und "andere Originale" zu Werken aus der Sammlung der Kunsthalle Bremen', *Doppelgänger*, exh. cat., Kunsthalle and Kunstverein, Bremen

Kramer, Hilton, 'The Wrights Have a Calling for Collecting', *New York Observer*, 15 March

Meister, Helga, '"Damenwahl": Katharina Fritsch/Alexej Koschkarow', *Kunstforum International*, No. 144., March/April

Merten, Ulrike, 'Museum mit Schwarz-Wald. Ein Entwurf von Katharina Fritsch', *NRZ*, 6 February

Richthofen, Alice von, 'Katharina Fritsch. Das ideale Museum', *Düsseldorfer Hefte*, March

Salvioni, Daniela, *Looking at Ourselves: Works by Women Artists from the Logan Collection*, exh. cat., Museum of Modern Art, San Francisco

Schenk-Sorge, Jutta, 'Die Macht des Alters: "Strategien der Meisterschaft"', *Kunstforum International*, No. 143, January/February

Shottenkirk, Dena, 'Fritsch's Fables: Katharina Fritsch's Artworks Draw on the Dark Side of Fairy Tales', *World Art*, No. 20, January

Szeemann, Harald, 'Katharina Fritsch', *La Biennale di Venezia, 48. Exposizione Internazionale d'Arte*, Electa, Milan

Winter, Marianne, 'Subjektive Spuren sind präzise getilgt. Städtische Galerie im Schloss Wolfsburg zeigt Arbeiten von Katharina Fritsch', *Wolfsburger Nachrichten*, 16 November

2000 Cecco, Emanuela de, 'Katharina Fritsch', exh. cat., *Quotidiana. Immagini della vita di ogni giorno nell'arte del xx secolo. The Continuity of the Everyday in 20th Century Art*, Castello di Rivoli and Edizione Charta, Milan

Cotter, Holland, 'Art in Review: Katharina Fritsch', *New York Times*, 9 June

Curiger, Bice; Heinrich, Christoph, *Hypermental. Wahnhafte Wirklichkeit 1950–2000 Von Salvador Dalí bis Jeff Koons*, exh. cat., Kunsthalle, Zurich; Kunsthalle, Hamburg; Hatje Cantz Verlag, Ostfildern

Dannatt, Adrian, 'Our Choice of New York Contemporary Galleries. Powerful De Koonings. Going at Watts, Coining it at Mattew Marks while Barbara Gladstone Rakes It In', *The Art Newspaper*, No. 104, June

Heymer, Kay, 'Katharina Fritsch', *Food for the Mind – Die Sammlung Udo und Anette Brandhorst*, exh. cat., Bayrische Staatsgemälde-sammlung, Staatsgalerie moderner Kunst, Munich, and Hatje Cantz Verlag, Ostfildern

Hondrich, Karl Otto, 'Das Zwischenmenschliche zieht uns hinab. Auch nach einer genetischen Verbesserung der Gesellschaft bliebe alles beim Alten', *F.A.Z.*, 22 April

Kino, Carol, 'Katharina Fritsch at Matthew Marks', *Art in America*, November

Meister, Helga, 'am horizont. Kaiser Wilhelm Museum Krefeld', *Kunstforum International*, No. 149, January/March

Zeitz, Lisa,' Chelsea, kaltes pochendes Herz der Kunst. New York hat noch einen Lieblingsspielplatz für Galeriegeher: Zwischen 6th Avenue und Hudson River', *F.A.Z.*, 20 May

2001 *Katharina Fritsch*, exh. cat. Museum of Contemporary Art, Chicago

Backhaus, Catrin, 'Catrin Backhaus über Katharina Fritsch', *Artist Kunstmagazin*, 2

Baker, Kenneth, 'Contemporary "Curiosities Cabinet" Mocks and Shocks', *San Francisco Chronicle*, 24 February

Glatt, Cara, 'Exhibit Reveals Ingrained Beauty at MCA', *Hyde Park Herald*, 4 April

Hawkins, Margaret, 'Boredom and Simplicity. Artists Display Disparate Views in MCA Show', *Chicago Sun Times*, 16 March

Meister, Helga, *Und keiner hinkt. 22 Wege vom Schwegler wegzukommen*, exh. cat., Museum Kurhaus, Kleve, and Kunsthalle, Düsseldorf

Rugoff, Ralph, *A Contemporary Cabinet of Curiosities. Selections from the Vicki and Kent Logan Collection*, exh. cat., California College of Arts and Crafts, San Francisco

Yood, James, 'Katharina Fritsch. Museum of Contemporary Art, Chicago', *Tema Celeste*, May

Photo Credits

Copyright

Lenders to the Exhibition

Emanuel Hoffmann-Stiftung, on permanent loan
to the Museum für Gegenwartskunst, Basel
Museum für Moderne Kunst, Frankfurt, on permanent
loan from the Dresdner Bank, Frankfurt
Kaiser Wilhelm Museum, Krefeld
Staatsgalerie, Stuttgart
Städtische Galerie, Wolfsburg
Sammlung Ackermans, Xanten
Daros Collection, Zürich
Katharina Fritsch, Düsseldorf

Index

italic figures refer
to illustrations